COMPLETE CANON
USER'S GUIDE

Canon EOS 500
Rebel X/S

[CD] **HOVE FOTO BOOKS**　　**Steve Bavister**

In North America
the Canon EOS 500 is known as the
Canon EOS Rebel X/S

All text, illustrations and data apply to cameras with either name.

First English Edition March 1994

Published by Hove Foto Books
Hotel de France, St Saviour's Road
St Helier, Jersey, Channel Islands JE2 7LA
Tel: (0534) 73102 Fax: (0534) 35354

Typeset by Jersey Photographic Museum

Printed by
The Guernsey Press Co Ltd, Commercial Printing Division
Guernsey, Channel Islands

British Library Cataloguing-in-Publication Data
A catalogue record for this book is available from the
British Library

Bavister Steve - Canon EOS 500/Rebel X/S

ISBN - 1-874031-25-8

Worldwide Distribution:

Newpro (UK) Ltd
Old Sawmills Road
Faringdon, Oxon.
SN7 7DS, England
Tel: (0367) 242411 Fax: (0367) 241124

The author would like to thank Canon Inc. for their assistance and permission for the
use of illustrations and drawings.

CONTENTS

NOTE TO NORTH AMERICAN READERS

The Canon EOS 500 is called that in all parts of the world except North America and Japan.

In North America, the equivalent camera is the EOS Rebel XS, which differs from the EOS 500 in only minor respects, relating mainly to the operation of the built-in flash and the style of one of the viewfinder and LCD displays, which are highlighted in the text. There is also a North American version, for which no equivalent exists elsewhere, called the EOS Rebel X, which lacks the built-in flashgun.

For the sake of convenience in this book, the camera will be referred to under the composite name of EOS 500/Rebel X/S. Where differences exist between models, they are described in the text.

In Japan, the camera is sold as the EOS Kiss Panorama, which has the same specification as the EOS 500, plus, as the name suggests, a built-in Panoramic option.

ACKNOWLEDGEMENTS

I would like to thank everyone who assisted in any way with this book, but in particular my children Helen and Jack, who've been wondering why they haven't seen their dad too much for the last couple of months. Now they know why.

FOREWORD

Congratulations! When you bought a Canon EOS 500/Rebel X/S you didn't just acquire another camera – you became the proud possessor of a superb picture-taking machine. Whatever you want to achieve in photography, this camera will let you do it.

Congratulations, too, on buying this book. It means you take owning your EOS 500/Rebel X/S seriously, and want to make the most of it. And that's what we're here to help you do. Page by page, section by section, we guide you in understanding the many features on the camera, and what it is they can do for you. Along the way, we pass on lots of practical hints and tips that will improve your general picture-taking competence.

And that's important. Because the more competent you are, the more confident you'll become, and the more confident you are, the more you'll achieve, and the more you achieve, the more pictures you'll want to take, and the more pictures you take, the better you'll get, and the better you get, the more you'll enjoy your photography, and the more you enjoy your photography, the more pictures you'll want to take...and so on.

So read this book carefully. Read it thoroughly. Learn what all the camera's controls are for. Practise using them, so you can operate them with military precision, even in the dark. Take note of the many tried-and-tested techniques you'll find in this book. Shoot lots of pictures, and learn from your mistakes. You'll get better, and it won't be long before family, friends and colleagues start clamouring to look at your latest batch of photographs. And when they do, they'll have just one word to say to you.

Congratulations!

Enjoy your photography,

Steve Bavister,
March 1994.

**Canon EOS 500/Rebel X/S
Kiss Panorama (Japan)**

INTRODUCTION

DESIGN & HANDLING

How time flies! It seems like only yesterday that the Canon EOS system burst upon a stunned and grateful photographic world – yet here we are, already looking at the 18th model in a long and distinguished line of EOS cameras, the Canon EOS 500/Rebel X/S.

As I'm sure you know if you own one, it's a superb, exciting, satisfying camera, and one that exemplifies all that is good about the EOS system. It will surely go on to become a best-seller, like the EOS 1000/Rebel which it succeeds.

In fact the first EOS camera, the ground-breaking EOS 600 (in North America the EOS 630), was launched in 1987. And right from the start it was clear that this was no run-of-the-mill range of SLRs, but something far more special. Not surprisingly, the EOS 600/630 quickly caught the interest of the camera-buying public, and it wasn't long before the EOS system began to challenge and then overtook the market-leading Minolta Dynax/Maxxum range.

A steady succession of EOSes followed, each bringing innovation and imagination to the design of SLR cameras. Look at the cameras since 1987, and you find yourself marvelling at the radical thinking and new ideas that the boffins at Canon produced: input dials, bar-code programming, custom functions, silent technology and USM lenses to name but a few. It's easy to see why Canon EOS has come to be the dominant SLR system around the world.

And the firsts continue: for while the Canon EOS 500/Rebel X/S brings nothing dramatically new to SLR design in the way of features, it's still innovative in terms of its size and weight. At the time of writing it's the smallest AF SLR with built-in flashgun.

SIZE MATTERS

Of course cameras were small and lightweight in the 1970s.

SLRs such as the Olympus OM1 and the Pentax ME-Super are legendary cathedrals of miniaturisation. But features-wise, by today's standards, they're out of the ark. They were simpler, but also, paradoxically, more difficult to use. You had to do pretty much everything yourself. Focusing was manual; metering systems were incredibly basic; film loading was fiddly, with winding-on done with your thumb; and using flash required the fitting of an accessory gun and complex calculations.

In those days, if you wanted to take good pictures you had to have a good understanding of the principles and practice of photography. There were lots of things that could go wrong, and not surprisingly, many photographers had difficulties. Taking pictures was regarded by many as a complicated and arcane craft – a mixture of mystery and magic – on a par with walking on fire or sawing the lady in half. And far too often the pressing of the shutter release was accompanied by a barely audible sigh of "Here's hoping they come out". And far too often they didn't.

Camera manufacturers, to their credit, saw the need to make cameras easier to use, and more foolproof. So they set out to eliminate, one by one, the problem areas of photography:

- Exposure systems became more sophisticated, and today's photographer can confidently leave it to his camera's on-board computer to let the right amount of light onto the film.

- Autofocus was introduced, got faster and more accurate, and now with the Canon EOS 500/Rebel X/S's wide focusing area, is improved again.

- Modern SLRs make flash photography as easy as mom's apple pie, as a result of having a "dedicated" flashgun built into the camera.

- And loading and unloading film these days couldn't be simpler, thanks to rapid motorised film loading, winding and rewinding systems

All this activity had created a range of cameras which were highly-specified, simple to use, and easy to get good results

from. But cramming all that technology in had exacted a high price – cameras had begun to get very big and bulky. And that was a problem. Canon, like most other on-the-ball companies, do lots of research into what their customers want – and one of the most important things they learned at the end of the 1980s was that amateur photographers had a very strong preference for smaller and more lightweight cameras. They discovered that the size of the cameras on the market were beginning to put some potential purchasers off.

So the challenge which Canon set themselves was to produce a fully-specified 1990s autofocus SLR in the size of a 1970s SLR body. There were those who said it couldn't be done. But where there's a will there's way. And necessity, being the mother of invention, eventually gave birth to Canon's new baby, the truly incredibly tiny Canon EOS 500/REBEL X/S.

Pick up the camera for the first time and you'll be amazed at how light it is. You might even find yourself wondering whether you've got a working model, or whether you're holding an empty case. But no, the Canon EOS 500/REBEL X/S weighs a mere 390grams with batteries installed. How on earth have they got the weight down? For those who like to know these things, here's how:

- the handgrip is much slimmer than on previous models

- a space-saving layout for the motor and main condenser has been used

- the film loading system is smaller

- the AF auxiliary light next to grip doubles as red-eye reduction lamp

- the built-in flashgun is smaller

- it uses 2x 3v batteries, rather than the bigger 6v in other EOSes

- and overall it has fewer parts – 369 (the EOS 1000FN/Rebel S II, in comparison, has 425).

It's not just weight, though, which sets the Canon EOS 500/REBEL X/S apart from its rivals. It's very small as well. Like a normal camera that's just come back from a couple of weeks on a health farm, the EOS 500/REBEL X/S is attractively slim and beautiful. Indeed, it's not much bigger than many zoom compacts on the market.

This combination of size and weight makes the Canon EOS 500/REBEL X/S very comfortable to hold and a pleasure to use. Some people, those with larger hands or those who've grown used to bigger cameras, may find the EOS 500/Rebel X/S too small. But Canon have prepared for that eventuality, by offering an optional grip, which is described in the Accessories section later.

THE CANON EOS 500/REBEL X/S – A FULLY-SPECIFIED AF SLR

Small it may be, but the Canon EOS 500/REBEL X/S nevertheless boasts an incredible array of picture-taking features. Think of it as Aladdin's lamp: tiny on the outside, but open it up and inside you'll find all this:

- a top shutter speed of 1/2000 second and a flash synchronisation speed of 1/90 sec
- a full range apertures
- wide-area multi-point autofocus with two different focusing options
- eight exposure modes and three metering patterns,including 6-zone evaluative metering
- a built-in TTL flashgun with red-eye reduction facility
- automatic pre-winding film loading and transport system
- a Multiple-Exposure option
- a self-timer facility

It's a tremendous specification, and owners of the EOS 500/REBEL X/S can pride themselves in possessing a

versatile and sophisticated camera that will almost certainly keep them happy for a picture-taking lifetime.

But you'll know already, if you've already had the pleasure and privilege of using an EOS 500/REBEL X/S, that, as with all EOS cameras, "sophisticated" doesn't mean "complicated".

Despite being full of state-of-the art technology, the camera remains incredibly easy to use. In fact, most people find they can pick it up and start using it after just a few minutes.

But Canon hasn't simply sought to make cameras easier to use. An important part of the company's philosophy is that it should do so while still allowing the user as much choice and control as possible.

So although there are automatic exposure modes, the photographer can still select the aperture and shutter speed himself if he wishes; although there is autofocus, the lens can be focused manually if preferred; and the experienced photographer can still get into flash calculation with an optional gun, if he or she wants.

GOOD TO HOLD – GREAT TO USE

The Canon EOS 500/REBEL X/S is not only good to hold, it's also great to use. Call it ergonomics, call it user-friendly design, call it what you like – but pick up the Canon EOS 500/REBEL X/S and the first thing you notice is how good it feels in the hands. Like all EOS cameras, it's clearly been designed with practical picture-taking in mind. Three fingers of your right hand wrap comfortably around the chunky handgrip while the right thumb presses into a curved panel to the right of the viewfinder to give a confidence-inspiring grip.

The key control is the chunky round one on the left-hand-side of the top-plate. This is called the Command Dial, and the main means of choosing your picture-taking mode. It turns freely, but locks positively at each position, to stop it getting knocked accidentally. More about the Command Dial options in the next section.

Probably the most important innovation in the design of the EOS range as a whole is the invention of the Main Input Dial. This clever rotating wheel, sited near the shutter release, gives fingertip control over a wide range of functions when combined with other buttons dotted around the camera. You use it to select shutter speeds, apertures, exposure compensation, along with other things. It's quick to use, making the camera fast and responsive.

If you've never used an SLR before, you'll find the user-friendly design of the Canon EOS 500/REBEL X/S lets you start taking top-quality pictures as soon as you've familiarised yourself with the controls.

CANON'S QUIET REVOLUTION

One of Canon's key contributions to the art and science of camera design has been their development of "silent technology".

It's intriguing how often the world turns full circle. Cameras always used to be quiet in operation: they had lenses you focused manually, a simple, silent shutter, and a thumb-operated lever you used to wind on the film. But over the years, with the addition of new features, cameras have become a lot more noisy.

An autowinder, with its distinctive chatter, now whisks the film through the camera. And a motor now helps the lens to focus, accompanied by its familiar and insinuating whirr. These sound have become such a taken-for-granted part of modern picture-taking that most of the time we're barely aware of them.

Canon's genius lay in recognising the obvious: that this noise pollution had reached a level where cameras could no longer be used in certain situations. At sports events or weddings, for instance, the atmosphere can be completely ruined by a badly-timed shot from a loud-mouthed camera.

Canon's conclusion was a simple one – that quieter cameras were needed. And they began what they call their quiet

revolution. They developed a new coreless motor and belt drive system to advance the film accurately and in virtual silence, and they introduced a range of lenses with Ultrasonic Motors (USM) that focused quickly, accurately, and very quietly.

Fitted with its standard EF 28-80mm USM lens, the Canon EOS 500/REBEL X/S is one of the quietest cameras currently available. There are few situations where it will cause sufficient disturbance to make it unwelcome.

IN SUMMARY

So far you've only had a brief introduction to the Canon EOS 500/REBEL X/S– and there's a lot more to come in the chapters that follow. But I hope that already you've got a sense of what an exciting an innovative camera it is– and how much I rate it. The Canon EOS 500/REBEL X/S is a superb SLR, and I know you'll enjoy using it. I certainly do.

NAMING OF PARTS
What everything's for

CAMERA (front view with flash up)

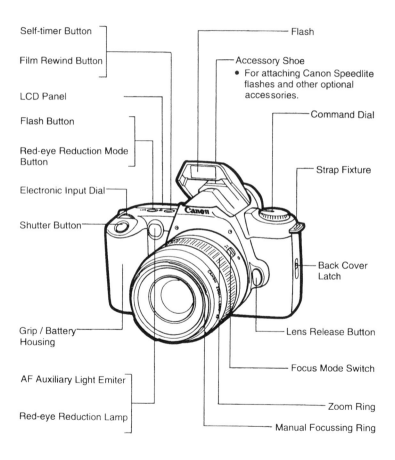

Self-timer Button

Film Rewind Button

LCD Panel

Flash Button

Red-eye Reduction Mode Button

Electronic Input Dial

Shutter Button

Grip / Battery Housing

AF Auxiliary Light Emiter

Red-eye Reduction Lamp

Flash

Accessory Shoe
- For attaching Canon Speedlite flashes and other optional accessories.

Command Dial

Strap Fixture

Back Cover Latch

Lens Release Button

Focus Mode Switch

Zoom Ring

Manual Focussing Ring

CAMERA (rear view with data-back)

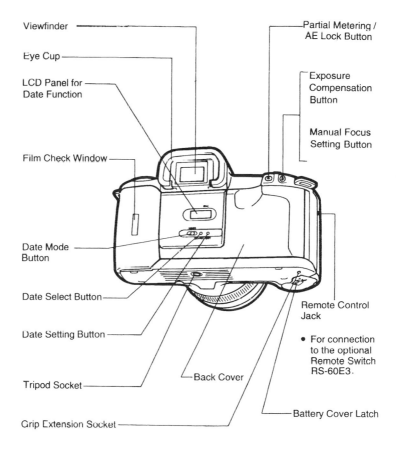

Viewfinder

Eye Cup

LCD Panel for Date Function

Film Check Window

Date Mode Button

Date Select Button

Date Setting Button

Tripod Socket

Grip Extension Socket

Partial Metering / AE Lock Button

Exposure Compensation Button

Manual Focus Setting Button

Remote Control Jack

• For connection to the optional Remote Switch RS-60E3.

Back Cover

Battery Cover Latch

AN INTRODUCTION TO THE OPERATING CONTROLS

Like most modern cameras, the Canon EOS 500/REBEL X/S is bristling with knobs and switches, and before you can really get to grips with the camera you need to know what they're all for. Let's take a look at the most important ones.

CONTROLS ON THE TOP OF THE CAMERA

Built-in flashgun
There's an Auto pop-up flashgun sited almost invisibly on top of the camera (not the EOS Rebel X). It's reasonably powerful (GN of 12m/ISO100), with coverage of lenses down to 28mm wide-angle, and useful for a wide variety of subjects at close range.

Command Dial
One of the key controls on the Canon EOS 500/REBEL X/S – the chunky one on the left of the top-plate which you use to

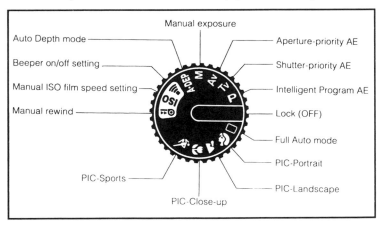

select the shooting mode. The red "L" position switches everything off, freezing all controls and preventing battery drain. Rotating the dial anti-clockwise brings the five fully automatic PIC (Programmed Image Control) modes into play.

Turning it clockwise gives access to the Creative Exposure modes, and other features.

Dedicated flash/accessory shoe
On top of the built-in flash there's a shoe which accepts accessory flashguns. It's equipped with electrical contacts that give "dedicated" flash linkage with Canon EZ series flashguns.

Flash Button
Press this down to activate the built-in flashgun in Creative Exposure Modes. In Image Zone Modes the flashgun is programmed to pop up, a bit like a startled frog, fire automatically, and pop back down again, as and when needed. (That's on the EOS 500, but not on the North American EOS Rebel XS, where you have to raise the flashgun manually in *all* modes. The EOS Rebel X has no built-in flashgun). A second press of the same button activates the camera's red-eye reduction mode.

Liquid-Crystal Display information panel
This important display on the camera's top-plate keeps you informed about what the camera's doing. It can get as busy as Times Square or Piccadilly Circus, but is easy enough to understand once you've familiarised yourself with what all the icons and abbreviations stand for.

Main Input Dial
A stroke of genius from the design gurus at Canon. This brilliantly-conceived control, operated by the right-hand index finger, is one of the main reasons why this and other EOS cameras are such a pleasure to use and so popular. It serves many functions: on its own for selecting shutter speed/aperture combinations; with other controls as a versatile input dial.

Self-timer button
Small button on the camera top-plate which sets the self-timer, giving you just 10 seconds to sprint around and put yourself in the picture. Can also be used in emergencies for firing the shutter when you haven't got a cable release.

Shutter release
How to be a Press Photographer – made easy: simply put your finger on the shutter release and press!

User film rewind
Half-way through a film and want to swap it for another? Turn the Command Dial as far clockwise as it will go, press in the dual-function switch to the right of the built-in flash (also used for self-timer), and get it rewound. Remember to make a note of how many frames you've exposed though!

CONTROLS ON THE BACK OF THE CAMERA

Exposure Compensation Button/Manual Aperture Setting Button
Dual-function button which 1) in Program, Aperture-Priority and Shutter -Priority modes allows setting of exposure compensation, and 2) in Manual mode gives control over both aperture and shutter speed.

Eye Cup
Well designed eye-cup cover that makes the camera more comfortable to use.

Film identification window
Small rectangular window in the camera back which allows you to check what film – brand, type, number of exposures – you've got loaded.

Partial Metering /AE-Lock button
When pressed locks exposure level until released. Also activates Partial Metering, which takes exposure from the central 9.5% of the picture area.

CONTROLS ON THE FRONT OF THE CAMERA

AF Auxiliary light emitter
When light levels drop too low for the EOS 500/REBEL X/S's focusing system to work accurately on its own, the built-in AF Auxiliary light whirrs into action and automatically emits a

beam of light to aid focusing. The same light is also used to give red-eye reduction.

Lens release button
Allows lens to be removed and changed for another. Hold the button down firmly and twist the lens anti-clockwise. Note: it is not necessary to hold the button down when *fitting* a lens.

Red-eye reduction lamp
Small but powerful lamp on the front of the camera body which lights up just before the flashgun fires, to minimise the likelihood of red-eye, the strange effect where people's eyes glow red, as if possessed by the Devil in some cheap 'B' movie. This is caused by the flash light being reflected back from the blood vessels at the back of their eye, and is most likely to occur when ambient light levels are low.

OTHER CONTROLS ON THE CAMERA

Battery cover latch
Well-designed latch which allows you to open the battery compartment quickly and easily to replace the two 3v lithium DL123A-type batteries. If you use the built-in flashgun a lot, you'll be needing it pretty regularly!

Slide the battery cover latch in the direction indicated so that the battery cover opens.

Camera back release
Simply push this switch down to open the camera back.

Remote control jack
Plug in your optional Canon Remote Switch RS-60E3 to

enjoy long exposures or avoid camera-shake by firing the camera's shutter without having to touch the camera.

Strap lug
Okay, so it's not much to get excited about, but you have to admit you'd be lost without somewhere to fix your strap.

Attaching the Strap:

Thread the ends of the neckstrap through the inside of the strap fixture as shown. Before using, tug the strap to ensure that it is firmly secured to the fixture.

Tripod Socket
Standard screw fitting at the base of the camera into which a tripod, monopod or other support can be threaded.

See opposite : Trinity College, Cambridge. Dazzling sun and deep shadows can be an exposure nightmare - yet the Canon EOS 500/Rebel X/S's Evaluative Metering system copes magnificently. Note how framing the scene with the archway gives an almost 3-dimensional sense of depth to the photograph.

Photo : Steve Bavister

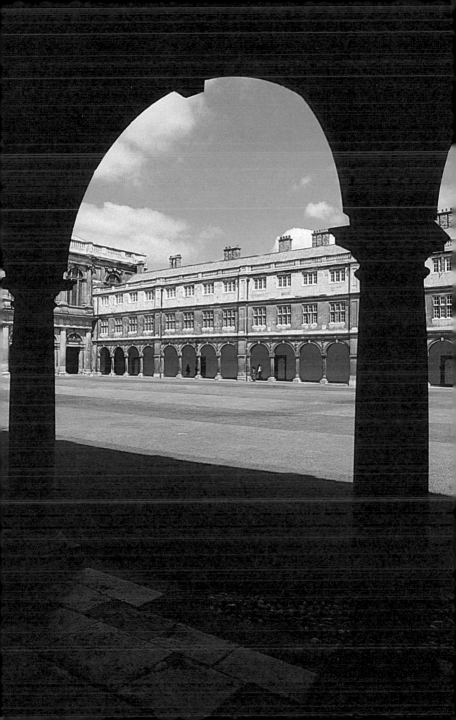

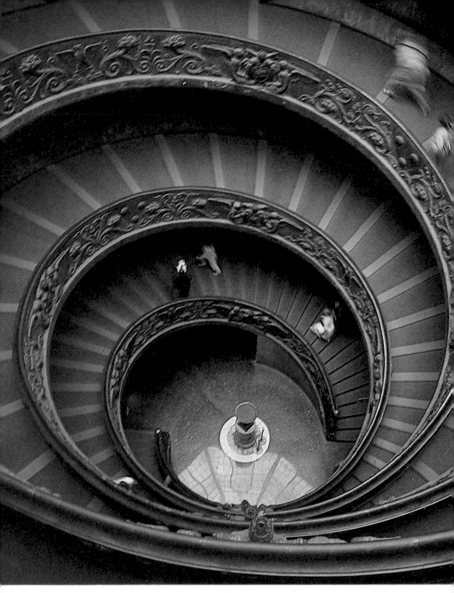

The spiralling lines of the stairway to the Vatican lead the eye down into the centre of the picture, with the sense of perspective enhanced by the use of a 17mm wide-angle lens. A slow shutter speed of 1/15 sec. allowed the people coming up the stairs to blur adding more interest than static figures would have done.

Photo : Steve Bavister

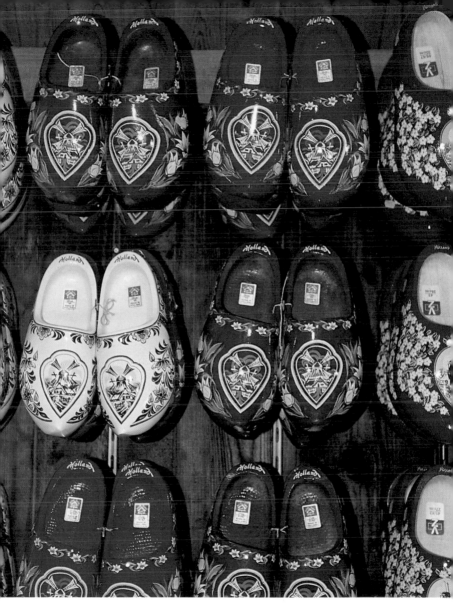

When travelling, keep your eyes peeled for local details that sum up the places that you visit. Here, brightly-coloured clogs equal Holland. The built-in flash means that additional light is always at your fingertips, ready for use whenever you need it.

Photo : Steve Bavister

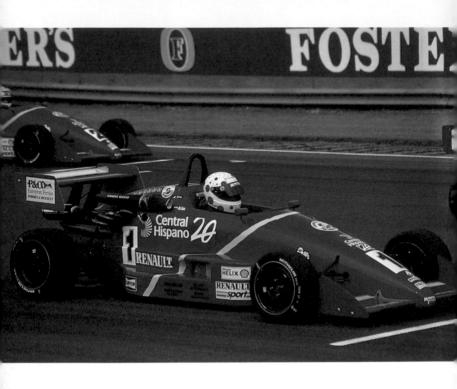

Many sports demand long telephoto lenses. To capture this racing car at the starting grid required a 400mm lens, with a 1/500 sec. shutter to achieve a pin-sharp result.

Photo : Steve Bavister

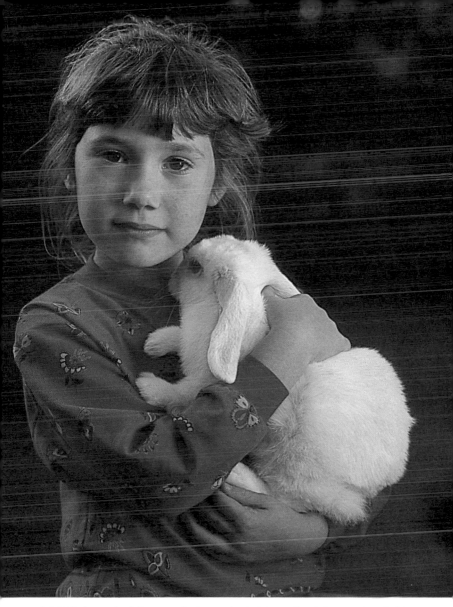

Light is important in any photograph, but here the late evening light has transformed what might have been an ordinary shot into something more special. Cropping in closely on the girl and her rabbit concentrates attention,

Photo : Steve Bavister

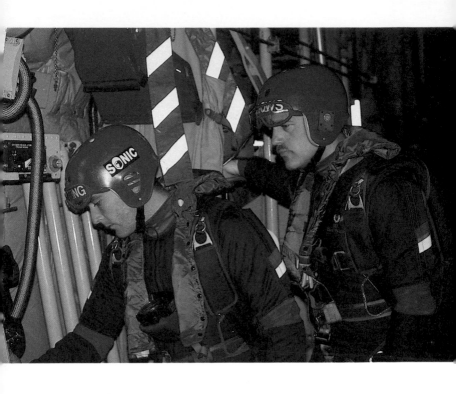

It's a tense moment as the RAF Falcons parachute display team prepare to hurl themselves from their Hercules transport aircraft. Capturing it on film is easy, though, thanks to the Canon EOS 500/Rebel X/S's sophisticated TTL (through-the-lens) flash system. Simply slip the 430 EZ flashgun onto the top of the camera, switch to program, and everything is worked out automatically for you.

Photo : Steve Bavister

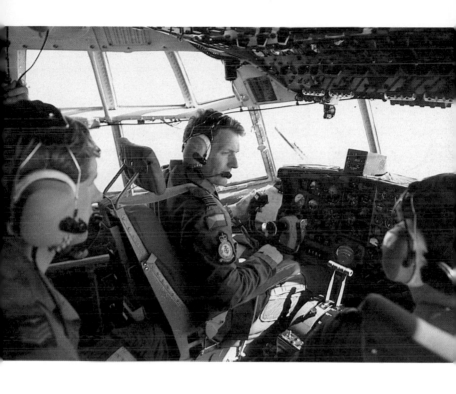

Cramped interiors always call for wide-angle lenses, and here a 20mm was required to get in all of the military aircraft's cockpit. Because of the strong light behind the subject, one-and-a-half stops exposure were required to give a correctly-exposed result.

Photo : Steve Bavister

Stained glass windows have to be approached with care. The best time to photograph them is on an overcast day, when the light outside is not too contrasty.

Photo : Steve Bavister

Capturing fine landscapes is easy with the Canon EOS 500/Rebel X/S's Landscape Mode. The camera automatically sets everything you need for front-to-back sharpness.

Photo : Steve Bavister

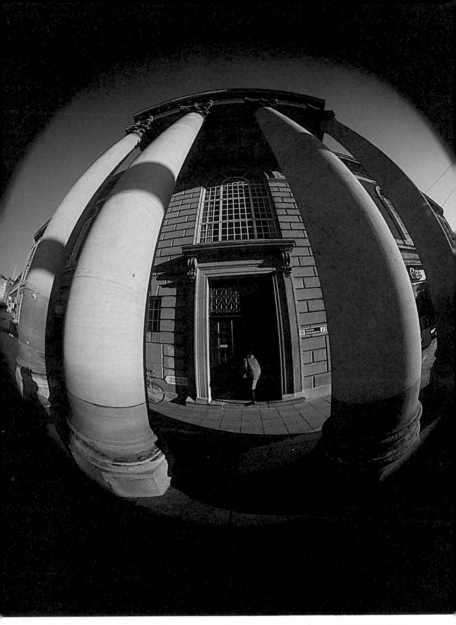

Fish-eye lenses produce dramatic circular pictures that transform everyday scenes into photogenic subjects - as here, where all the straight-lined pillars of a town hall go bendy.

Photo : Steve Bavister

STAYING INFORMED
Lcd panel & viewfinder

The more sophisticated a camera becomes, the more important it is that the photographer is kept informed. If you want to take really good pictures, you need to know what's going on.

In this respect the Canon EOS 500/REBEL X/S is unrivalled, offering two exceptional ways of staying informed: the LCD panel on the top-plate of the camera, and an LCD strip which runs below the picture area in the viewfinder.

Both are clear, very easy to read, and work extremely well. Some of the information they carry is the same, some different. Let's take a close look at each in turn.

TOP-PLATE LCD PANEL
at-a-glance

The following items are all indicated in the figure below.

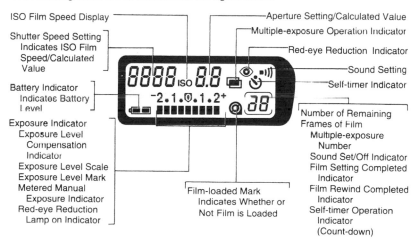

ISO Film Speed Display

Shutter Speed Setting
Indicates ISO Film
Speed/Calculated
Value

Battery Indicator
Indicates Battery
Level

Exposure Indicator
Exposure Level
Compensation
Indicator
Exposure Level Scale
Exposure Level Mark
Metered Manual
Exposure Indicator
Red-eye Reduction
Lamp on Indicator

Aperture Setting/Calculated Value

Multiple-exposure Operation Indicator

Red-eye Reduction Indicator

Sound Setting

Self-timer Indicator

Number of Remaining
Frames of Film
Multiple-exposure
Number
Sound Set/Off Indicator
Film Setting Completed
Indicator
Film Rewind Completed
Indicator
Self-timer Operation
Indicator
(Count-down)

Film-loaded Mark
Indicates Whether or
Not Film is Loaded

VIEWFINDER INFORMATION PANEL
at-a-glance

The following items are all indicated in the figure below.

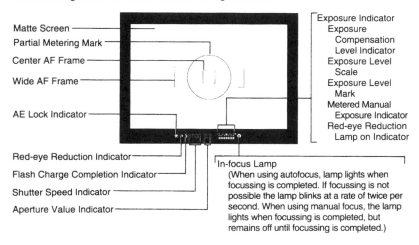

Matte Screen

Partial Metering Mark

Center AF Frame

Wide AF Frame

AE Lock Indicator

Exposure Indicator
Exposure
 Compensation
 Level Indicator
Exposure Level
 Scale
Exposure Level
 Mark
Metered Manual
 Exposure Indicator
Red-eye Reduction
 Lamp on Indicator

Red-eye Reduction Indicator

Flash Charge Completion Indicator

Shutter Speed Indicator

Aperture Value Indicator

In-focus Lamp
(When using autofocus, lamp lights when
focussing is completed. If focussing is not
possible the lamp blinks at a rate of twice per
second. When using manual focus, the lamp
lights when focussing is completed, but
remains off until focussing is completed.)

TOP-PLATE (LCD)
(LIQUID-CRYSTAL DISPLAY) PANEL

The top-plate LCD (Liquid-Crystal Display) panel on the
Canon EOS 500/REBEL X/S really is a first-class piece of
design. Although tiny, it nevertheless carries a wealth of
information about many different functions – all with a clarity
of purpose that stops it from ever getting confusing.

At first, of course, the panel will look a little daunting, but
once you get used to it, you'll soon feel more confident, and
see what's going on instantly.

TOP-PLATE LCD INFORMATION

With the Command Dial locked in the "L" position, and the
camera effectively switched off, you have a limited amount of
information available to you.

The key thing you can tell at a glance is whether or not the camera is **loaded with film.** If it's empty, the LCD panel will be blank apart from two rectangular panels. If the camera does have film in it, you'll see a small round icon, like a film cassette viewed from the top, along the bottom right-hand of the LCD. You'll also observe a figure in brackets in the top right corner which indicates the **number of pictures remaining on the roll.**

Switch the Command Dial to any of the camera's exposure modes, and you'll see the top-plate panel come alive. Both the film loaded icon and the number of pictures remaining to be taken are visible, but there is also a wealth of additional information.

Much of the technical skill in taking pictures lies with the creative choice of **aperture and shutter speed**, so it's crucially important that the photographer is kept fully informed as to what's happening exposure-wise. Canon's designers are obviously very keen photographers themselves, because they've quite rightly made sure that the aperture and shutter speed figures are the biggest and clearest thing on the top-plate panel.

The apertures run in half stop increments, in the standard sequence of f/1, f/1.4, f/1.8, f/2, f/2.5, f/2.8, f/3.5, f/4, f/4.5, f/5.6, f/6.7, f/8, f/9.5, f/11, f/13, f/16, f/19, f/22, f/27, f/32, and are displayed as simple digits, i.e. 4.5 or 16. The precise range of apertures available will be determined by the lens fitted to the camera.

The shutter speed range of the Canon EOS 500/REBEL X/S is an extensive one, from an action-stopping 1/2000 sec to a night-scene-capturing 30 seconds.

Fractions of a second (i.e. 1/2 sec to 1/2000 sec) are

displayed as equivalent numbers – so 1/2 sec is shown as 2, and 1/2000 sec as 2000. Speeds of one second or longer are displayed as the time followed by a double apostrophe – so one second appears as 1", and 30 seconds as 30".

For most people it takes no more than a couple of rolls of film to get used to how the apertures and shutter speeds are displayed. After that, they can see at a glance the situation on the exposure front.

Fine-tuning exposure in the Creative Exposure Zone is quick and easy on the Canon EOS 500/REBEL X/S using the **exposure compensation system**. This is indicated on the bottom of the top-plate as a range of numbers from -2 to +2. To set the degree of exposure compensation required, press in the Exposure Compensation Button on the back of the camera, then rotate the Main Input Dial and you'll see the black cursor on the display move back and forth.

Similar exposure compensation can also be applied to the built-in flashgun, simply by pressing the flash activation button to the right of the pentaprism. The procedure is the same as above.

There are two buttons on the camera top-plate on the other side of the LCD panel. The first, to the left, is dual-function,

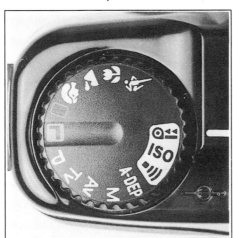

acting as both the self-timer and film rewind button. Want to use the **self-timer**? Press down once and you'll see the circular self-timer icon appear towards the top right of the top-plate display.

If you want to **rewind a film** before it's finished, turn the Command Dial to the ⊙⇄ position,

press in the film rewind button (the left of the two in front of the LCD panel on the top-plate) and hold it in for at least one second. The film will rewind, and the flashing film icon will show.

A press on the button closest to the Main Input Dial activates the **built-in flashgun**, causing it to pop up. It will then fire automatically for every shot until pushed down. Pressing the same button again accesses the EOS 500/REBEL X/S's **red-eye reduction system.** The LCD display shows a solitary eye at the top of the display.

Press in together the two buttons near the right thumb, and you access the camera's **Multiple-Exposure** system. The display consists of the multiple-exposure icon 🔳 and the number 1. Rotating the Main Input Dial changes the number to indicate the number of multiple-exposures required – up to

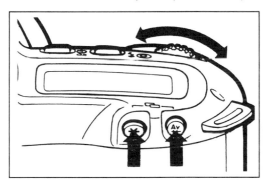

a maximum of 9. You opt, for instance, to put 5 exposures on one frame by selecting 5. After a few seconds the display returns to normal, but with the figure five in the bottom right-hand corner, where the number of pictures taken would normally be shown, and the multiple-image icon also shown. Then, as you take your multiple-exposures one by one, the camera counts down for you, 4, 3, 2, and 1. After the first shot has been taken the multiple-exposure icon flashes on and off, to remind you that you're in the middle of a series of multiple-exposures. Once the cycle is complete, the display will return once again to normal.

Do you like a noisy camera or a quiet one? If you prefer not to hear audible confirmation that the lens has focused, or that camera-shake is likely, you can switch the audible bleeper off by rotating the Command Dial to the XX position ◀)) , to cancel the camera's **audible beep**, which is used to confirm focus and give warning of possible camera-shake. Use the main input dial. A 1 means it's activated, 0 means it's switched off.

If you want to check the **speed the film** in the camera is currently being rated at, simply rotate the Command Dial to the "ISO" setting. A number, between 6 and 5000 ISO, will be displayed.

The full range runs in one-third stop increments, as follows: 6, 10, 12, 16, 20, 25, 32, 40, 50, 64, 80, 100, 125, 160, 200, 250, 320, 400, 500, 640, 800, 1000, 1250, 1400, 1600, 2000, 2500, 3200, 4000, 5000, 6400.

To change film speed, rotate the Command Dial to the "ISO" position to call up the ISO display, then turn the Main Input Dial until the film speed you require is shown, and then return the Command Dial to your preferred picture-taking position.

VIEWFINDER INFORMATION

Designers of viewfinder information panels have a tricky job to do. On the one hand, they have to make them clear and easy to read, yet on the other they must take care not to distract attention away from the viewfinder image itself.

Thankfully, in the Canon EOS 500/REBEL X/S, the designers have got it just right. Forget the busy top-plate LCD, the information panel in the viewfinder – a long, thin strip along the bottom of the picture-area – is a model of sparseness and simplicity. With yellow numbers reading out of a background of green, the viewfinder LCD is very relaxing and pleasant to look at, yet presents its information with tremendous clarity.

The viewfinder display panel is switched on by first pressure on the shutter release, and then in normal use stays visible

for six seconds after pressure has been released. The viewfinder itself is reasonably bright, clear and shows 90% vertical and 90% horizontal of the actual picture-area.

Once again, the two things you really need to know when you're taking a picture are the **aperture and shutter speed**. Anything else is useful, but secondary. If anything, it's more important that exposure information is clearly displayed in the viewfinder, because the last thing you want to do is to have to keep taking your eye away from the viewfinder to check something on the top-plate.

And once again, Canon have got it bang on. Clear, bold numbers, following the style of those on the top-plate, tell you at-a-glance just what the aperture and shutter speed are.

We've already talked, when discussing the top plate LCD above, about what a fiddly business **exposure compensation** is on most cameras, yet how comparatively simple it is on the Canon EOS 500/REBEL X/S. One of the reasons for the system's success is that you can set the required compensation without having to remove your eye from the camera. Look at the right hand side of the viewfinder information strip and you'll see a copy of the exposure compensation display on the top-plate LCD. And as you make fine-tuning exposure adjustments, operating the over-sized Quick Control Dial with your thumb, you can keep pace with what's happening in the viewfinder. Note: the North American Rebel X and Rebel XS use a different, +/– display.

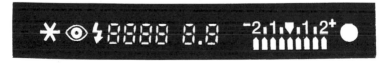

Much of the design of the Canon EOS 500/REBEL X/S seems to have been modelled on the Chameleon, with controls capable of changing character at a moment's notice. Switch the Command Dial to Manual Exposure, for instance, and the viewfinder compensation dial suddenly transforms itself into a modern electronic version of the old matched-

needle metering system, complete with a flashing cursor to highlight over- or under-exposure.

This happens once again when the camera's integral flashgun is brought into use. The viewfinder compensation display then magically transforms itself into yet another type of display, one which shows the flash charging up and ready to fire. Incredible! A lightning strike flash icon also appears on the left-hand of the viewfinder LCD, to confirm flash is being used, and an "eye" icon is visible if the red-eye reduction facility has been set.

When the AE-Lock button, which falls underneath the right thumb, is in use, an asterisk appears at the far left of the viewfinder LCD strip, while at the far right of the strip, a green circle is displayed every time the autofocus system achieves focus.

WARNINGS

The viewfinder panel also serves another function, warning you when things are not right. If you're in Av (aperture-priority) Mode, for instance, you might see the shutter speed display flashing. This indicates that the camera is unable to set a shutter speed that corresponds to the aperture you've selected – and you need to choose a more appropriate aperture.

A similar thing can happen in Tv (shutter-priority) Mode. A flashing aperture indicates a need to choose a different shutter speed.

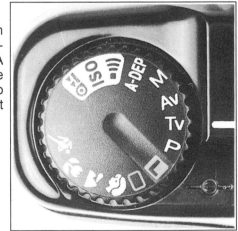

GETTING STARTED
Shooting your first film

Unless you're a techno-maniac, who loves photographic equipment for its own sake (and nothing wrong with that!) you'll almost certainly have an overwhelming desire to get your first film loaded in the camera, shot, and processed, so you can show the resulting masterpieces to your family and friends.

That's only natural. But if you're to get the best from an advanced camera such as the Canon EOS 500/REBEL X/S you need to spend some time learning all about how it works – and reading this book thoroughly will give you the understanding you need. In the meantime, though, here's a brief guide to getting your Canon EOS 500/REBEL X/S on the road *now*.

INSERTING THE BATTERIES

Like most modern cameras, the Canon EOS 500/REBEL X/S is wholly dependent on battery power, so it goes without saying that you need to insert the batteries before you can start taking pictures. This is done by unclipping the latch at the base of the camera's handgrip.

The Canon EOS 500/REBEL X/S is powered by two lithium C123A-type batteries, and it's important to follow the directions on the inside of the battery cover to make sure you fit them correctly. Close the battery cover and take a peek at the top-plate LCD panel. In the bottom left corner you'll see an AA-battery-shaped icon which tells you how much power is left in the battery.

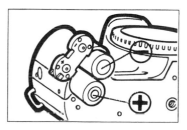

Insert the batteries with the + and - terminals pointing in the correct direction as indicated on the battery cover.

Close the battery cover.

Assuming you've put the batteries in for the first time, the whole of the icon should be black, indicating they're in good condition. If nothing is displayed, then you may have inserted the batteries backwards. Double-check that they are in right. If that's not the problem, then it's probably a good idea to pop back to the store where you bought the camera for advice. Once the camera is working okay, progressively, as you use it, the battery icon will change to half black, then to empty, and when close to exhaustion will start blinking.

A good time to get a replacement set of batteries is when the icon changes from full to half. Lithium batteries have a long shelf life – that is they stay fresh for quite a long time unused – so it's sensible to have spares should you suddenly need them.

The actual life of the batteries depends on a number of different factors: see later in this book for full details of how to maximise battery life.

FITTING THE LENS

In its simplest form, a camera body is really nothing more than a light-tight container that holds the film – although, admittedly, in the case of the Canon EOS 500/REBEL X/S, a rather sophisticated one!

To remove the lens, turn the lens in the direction of the arrow on the lens while pressing the lens release button until it stops.

Obviously the body alone won't get you very far, and you need to fit a lens before you can start taking pictures. If you've never done this before you might be a bit nervous about getting it wrong and messing something up. But really there's no need to worry as long as you take things carefully. All you have to do is:

* hold the camera body in your right hand, with the lens mount pointing towards your left hand

* pick up the lens with the front element in the palm of your hand

* bring the two items together

* align the red dot on the lens with the red dot on the camera

* and twist the lens clockwise, gently but positively, until you hear a click and the lens won't move any more.

To remove the lens, first press in the lens release button, and then simply reverse the procedure outlined above.

LOADING THE FILM

To load the film, you must first move the Command Dial position to anything other than "L", otherwise nothing will happen. Then you simply:

- open the camera back
- drop the film cassette into the left-hand chamber upside-down
- hold onto the cassette with your left hand and use your right to pull the film leader across to the orange mark
- close the camera back, and
- hear the camera wind out the film to the end of the roll (it has a useful pre-wind system about which more later) which will take up to 15 seconds for a 36-exposure roll
- check the top-plate LCD panel to ensure that the frame counter shows "24" or "36" or whatever the length of film is. If the film cartridge icon is blinking, the film has not been loaded correctly. Open the back, pull out the film leader a little more, and try again.

NB: Take great care not to let your fingers near the blades of the shutter. These are very delicate, and even the slightest touch can lead to an expensive repair bill.

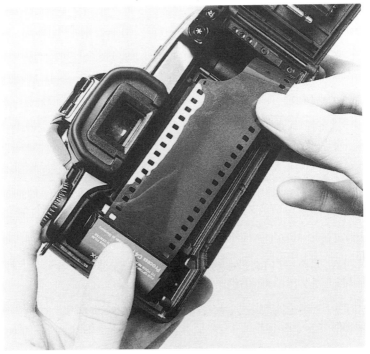

SWITCH TO GREEN RECTANGLE MODE

If you want to start shooting but don't right now want to get to grips with the camera's full range of features, then there's a simple solution: use the fully-automatic "Green Rectangle" mode. This is a picture-taking mode that's pre-set for general photography, and which will take care of all the technicalities for you. Select it by rotating the camera's top-plate Command Dial to the Green Rectangle position and you're ready to roll.

FIT THE STRAP

And finally, before you go out, fit the strap. For two reasons:

1. It's a lot easier and more comfortable carrying the camera around when it's got a strap on it, and

2. It's a lot safer. Cameras are more easily dropped with no strap, and it would be a great shame for you to have to cart your precious EOS 500/REBEL X/S back to your photo dealer for repair.

LET'S GO!

And so you're ready.

Pick the camera up, wrap three of the fingers of your right hand around the hand-grip, and let the fourth, the index finger, fall perfectly onto the shutter release button.

Put the camera to your eye and frame the scene before you.

Press down gently: feel the lens whizz into action, hear a beep to confirm that it's focused, see exposure details appear in the viewfinder.

Squeeze the shutter release more firmly: hear the shutter fire satisfyingly and the film wind quietly on.

Congratulations! You've taken your first picture with your Canon EOS 500/REBEL X/S. The first of many.

THE AUTOFOCUS SYSTEM

The Canon EOS 500/REBEL X/S focuses with startling rapidity, far quicker than even the most-experienced professional could ever hope to achieve manually.

Not only is it fast, especially with USM (Ultrasonic Motor) lenses, it's also very accurate. In fact it's fair to say that autofocus has improved the overall quality of picture-taking enormously. It's especially a great boon for people with visual difficulties – and from the age of 40 most people start to see a steady deterioration in the quality of their vision.

Autofocus in SLRs first appeared in a satisfactory form in 1985, and since then has got faster and more accurate. As you might imagine, Canon have been at the forefront of companies improving autofocus, and the introduction of the EOS 500/Rebel X/S marks another milestone in the design of AF systems.

One of the big problems with autofocus to date has been its inability to cope effectively with subjects not in the centre of the picture-taking area. Traditional autofocus SLRs, which have a small, often round focusing point in the middle of the viewfinder, can miss such subjects – producing out-of-focus and unsatisfactory pictures.

What makes the EOS 500/Rebel X/S so special is its innovative Multi Wide Focus system. This boasts a much larger, rectangular, focusing area than conventional cameras and because this covers a greater proportion of the picture-taking area, it catches more off-centre subjects – preventing out-of-focus pictures.

In fact, there are three focusing points, horizontally across the viewfinder, and when you take a picture the camera automatically selects what it thinks is the right one. It does pretty well, too, with a surprisingly high degree of accuracy. But like any automated system it can't be relied upon 100%. It will occasionally get it wrong, so you need to keep an eye on what it's up to.

Selecting just one central point is possible. Simply press in the A-Lock button, on the camera back, marked with an *, and only the central square of the viewfinder focusing area is active.

Like other EOS cameras, the 500/Rebel X/S has a TTL-SIR (Through-The-Lens − Secondary Image Registration) focusing system. To achieve Multi Wide Focus it uses a multi-BASIS sensor, with a vertical focusing sensor positioned on either side of the central cross-type BASIS focusing sensor. (BASIS stands for Base Stored Image Sensor). The system is sensitive down to 1.5EV.

If all this sounds gibberish to you, don't worry. You don't need to know how it works to make it work. What's important is understanding when the system works well, and when it has problems.

In simple terms, focusing in the EOS 500/Rebel X/S is based upon contrast in the picture. With strong contrast in the scene it will focus quickly and accurately; with poor contrast it will be less positive, and in extreme cases it may not be able to focus at all. In such cases you should switch to manual focusing (see later).

Light levels are important too. Although the system will focus unaided by the light of a single candle, it may be a little hesitant − and all things being equal the more light there is the faster and more positively it will focus. However, if necessary in low light situations it has a trick up its sleeve − or rather on its front. That's where you find its AF halogen-type krypton lamp which it calls upon to help focus when it starts to have difficulty. This has a range of about 5m.

There are two focusing modes available: One Shot AF and One-Shot AF/AI Auto Switching. These are selected automatically by the camera, according to the shooting mode.

ONE SHOT AF

One Shot AF is set in the following modes: Portrait, Landscape, Close-up and A-DEP. Simply press the shutter

release part of the way down and the lens will focus, and you'll hear a beep and see the green focus confirmation light in the viewfinder illuminate. The lens will stay focused on that point until you take the pressure off the shutter. So you can, if you wish, reframe the composition before taking the picture.

One important benefit of this mode is that you can't take a picture until the camera has successfully focused – and that means it's very difficult to take out-of-focus pictures.

Sometimes, if the subject has very little contrast or light levels are low, the lens will find it difficult to focus. In those situations, see if you can find something the same distance away from the camera which has more contrast, because that's what the camera's autofocus system needs to "bite" on.

ONE SHOT AF/AI AUTO SWITCHING

One-Shot AF/AI Auto Switching is set in the following modes: Green Rectangle, Sports, Program, Aperture-Priority, Shutter-Priority and Manual.

The Canon EOS 500/Rebel X/S is a clever camera. For general picture-taking in these modes it selects One-Shot AF, and operation is as described above. But when it senses movement, it switches automatically out of One Shot AF and into AI Servo AF. In this mode the lens continuously focuses and refocuses as necessary, as long as pressure is applied to the shutter release button.

Not only that, it also has predictive ability, in that it can calculate the speed and direction of the subject. Yes it's true! Normally the only problem is that there's a delay, just a short one, between the pressing of the shutter release, the mirror flipping up, and the shutter actually opening and then closing. For static subjects it's not a problem, but with fast-moving subjects it is, because by the time the shutter has opened your subject has moved, and it will be out of focus.

But with the Canon EOS 500/REBEL X/S you have no such problem. The system automatically calculates where the subject will be, and sets focus accordingly, for perfectly-sharp

pictures every time. Even if the subject is moving.

FOCUSING MANUALLY

Given the amount of time and effort Canon have expended in developing the EOS autofocusing system, you'd be forgiven for thinking that manual focusing might probably be a bit of an afterthought – and not very good.

But that's not Canon's way. They seek to make their cameras perform with excellence in *every* area – which is one of the reasons why they enjoy the pre-eminent position in the SLR market that they do.

In fact, the manual focusing on the EOS 500/REBEL X/S is exceptional, as it is on other EOS cameras. The viewfinder image is clear and bright, and you still have the benefit of the yellow circle in the viewfinder LCD strip which lights to confirm focus. To switch to manual focusing all you have to do is slide the switch on the lens marked AF/M back towards the camera, the M position, then turn the serrated focusing ring on the lens.

Why would anyone want to focus manually when autofocus is now so good? Maybe they shoot a lot of fast sport and action, and like to pre-focus – i.e. focus on a point and wait till the action comes into it – which it's easier to do in manual. Or perhaps because they're used to manual focusing, they like it, and simply prefer to stick with it.

THE EXPOSURE SYSTEM

The key thing to understand about exposure systems in cameras is that they have two distinct but complementary functions. Number One, they measure the amount of light in the scene to be photographed, and Number Two they make sure the right amount of light ends up on the film. Let's take a look at each of these functions in turn.

EXPOSURE MEASUREMENT

The principles of exposure measurement are simple enough. You've got a film in your camera which has a certain sensitivity to light, denoted by an ISO (International Standard Organisation) number. Let's say it's ISO 100.

Now, to get the best results from this film you have to make sure that the right amount of light falls onto it. And that's where the camera's meter comes in. Its purpose in life is to measure the intensity of the light, and it does this by taking the light reflected back to the camera by the various elements in the picture and then averaging it out to a mid-grey, which is what years of experience have shown that a typical scene integrates down to.

That's how a basic metering system works. But the Canon EOS 500/REBEL X/S is blessed with a far more sophisticated 6-zone Evaluative Metering system. It's what they call an "intelligent" system, because the processing power it brings to the calculation of exposure makes errors virtually a thing of the past.

If you've ever played chess with a computer, you'll know how hard it is to win. Skilfully programmed, computers make formidable enemies. Set them up to assist you, though, and they make formidable allies.

With its 6-zones, built around the Multi Point Focusing area, the EOS 500/REBEL X/S's meter can take account of the subject size, the overall lighting level, front lighting and back lighting, and – here's the really *clever* thing – the focusing point in use. So if your subject's over to the left, that's where

EOS 500 Metering Sensor

the camera focuses – and that's where the meter automatically places its emphasis.

In creating the 6-Zone Evaluative metering system, Canon analysed thousands of different kinds of photographs and stored the information so that future scenes could be compared against it – and exposure compensation given automatically when required.

In all the time I've been using the EOS 500/REBEL X/S, the Evaluative Metering system has proved its ability in a wide range of situations, and can be relied upon with confidence.

However, if you like playing around, you might like to try out the partial metering option which can be set in Program, Aperture-Priority, Shutter-Priority and Manual modes. This allows you to meter from just a small part of the viewfinder area, the central 9.5%. You do this by pushing in the AE-Lock button, marked with an *, at the back of the camera. Partial metering is useful if you want to be sure your exposure is correct in situations such as very strong backlighting.

EXPOSURE CONTROL

Exposure control is all about putting that right amount of light onto the film in the best way. At your disposal you have two controls, the aperture and the shutter, each of which can be used to let through a controlled amount of light.

The **aperture** is nothing more than a hole in the lens whose size can be varied, and apertures are marked with a strange and baffling series of numbers, called f-numbers or f-stops: f/1.4, f/2, f/2.8, f/4, f/5.6, f/8, f/11, f/16, f/22, f/32. There are five key things you need to understand about apertures:

1. that, confusingly, the low numbers describe big holes, and

are called big or wide apertures, and the high numbers describe tiny holes and are called small or narrow apertures,

2. that each progression along the scale represents a doubling or halving of the light let in, so f/5.6 lets in twice as much light as f/8 but only half as much as f/4.

3. that each doubling or halving of light is known as a "stop". So f/8 lets in one stop more than f/11 and two stops more than f/16. And

4. that there are also "half-stops" which go between the stops − you'll see them on the viewfinder and top-plate LCD panels. For instance the half-stop between f/5.6 and f/8 is f/6.7, and the half-stop between f/11 and f/16 is f/13.

5. that a given aperture is the same on all lenses. That is, f/8 on a wide-angle lets in the same amount of light as on a telephoto lens.

Shutter speeds operate in a similar way. Their series, though, is more obviously logical, running, on the Canon EOS 500/REBEL X/S as follows:
1/8000 sec, 1/4000 sec, 1/2000 sec, 1/1000 sec, 1/500 sec, 1/250 sec, 1/125 sec, 1/60 sec, 1/30 sec, 1/15 sec, 1/8 sec, 1/4 sec, 1/2 sec, 1, 2, 4, 8, 15 and 30 seconds. Once again, these are all full stop gaps, with each representing a doubling or halving of the light let through − a shutter speed of 1/30 sec admitting twice as much light as the briefer 1/60 sec. And, once again, when you look on your LCD panels you'll find half-stops: 1/3 sec, 1/6 sec etc.

In most situations there are several ways in which the aperture and shutter speed could be combined to give the same exposure, and choosing the right combination is one of the keys to successful photography.

For instance on a sunny day, with ISO 100 film, the following exposures would all let in the same, right amount of light:

1/60 sec	1/125 sec	1/250 sec	1/500 sec	1/1000 sec
f/16	f/11	f/8	f/5.6	f/4

However the effect would be very different. Without getting too deeply into it, shutter speeds control any movement in the picture, freezing or blurring it, while apertures control depth-of-field, the zone of acceptable sharpness in front of and behind the point actually focused on. So the 1/60 sec and f/16 option would have a lot more of the picture sharp, although any moving subject would probably blur, while the 1/1000 sec option would freeze any movement but not have the same amount of the scene sharp.

EXPOSURE MODES

There are various ways in which you can approach the choosing of aperture and shutter speed combinations, and these are called Modes. On the CANON EOS 500/REBEL X/S you have several different Modes to choose from, including "Image Zone Modes" and "Creative Exposure Modes". We'll be looking at each of these in turn in later sections, considering what they do, and how to make the most of them.

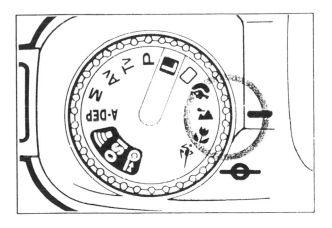

THE FILM TRANSPORT SYSTEM

They say that silence is golden – and Canon prove it with the EOS 500/REBEL X/S, a camera so quiet in use that most of the time you don't even hear it wind on after a shot. Canon describe the EOS 500/REBEL X/S's film transport system as "whisper-quiet", and although that sounds like just another piece of advertising hype, it's not far from the truth. By comparison, other cameras on the market suddenly seem unpleasantly – and unacceptably – noisy. So how was it that Canon managed to make the Canon EOS 500/REBEL X/S seen but not heard? There are a number of ways.

Other cameras have sprockets which engage with perforations along the edges of the film to ensure the film moves forward the correct distance, and inevitably this creates noise. The Canon EOS 500/REBEL X/S, on the other hand, has a sprocketless optical detection system which bounces an infra-red beam off the film and counts the sprocket holes as they pass. The good news is that it's completely noiseless. The bad news is that because of it you can't use infra-red film in the camera.

On most cameras, film wind and rewind is via a noisy gear chain. On the EOS 500/REBEL X/S this has been replaced by an almost-silent belt drive system.

Coreless motors, which produce minimal noise and reduced vibration have been introduced in place of standard types, and extensive use has been made of acrylic and foam to isolate vibrations

The end result of all this "silent technology", as Canon like to call it, is a camera that's so quiet in use that it rarely draws attention to itself. And that means you can use it in situations where a camera would not normally be welcome – such as at a wedding ceremony or sports event.

LOADING A FILM

Loading a film into the Canon EOS 500/REBEL X/S is a quick and easy job. You just open the camera back by means of

the catch on the left-hand side, drop your cassette in upside down, pull the film leader across until it reaches the orange mark, and then close the back again. The whole job from start to finish takes less than 10 seconds.

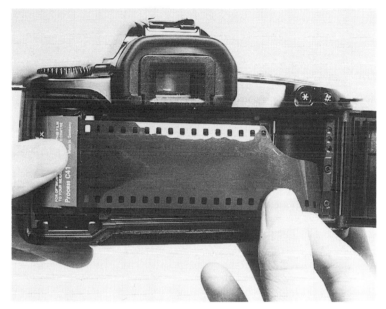

Of course it goes without saying that when you load a film into your camera you have to do it properly. Fluff it, and you kiss goodbye to 36 lovingly-taken pictures. But messing up your film loading is something you don't have to worry about on the EOS 500/REBEL X/S – it's impossible to get wrong.

Unusually for an SLR, the Canon EOS 500/REBEL X/S has a film pre-wind system. That is to say, that when you load the film into the camera, it's all wound out of the cassette and onto the take-up spool. And every time you take a shot, the piece of film you recorded it on gets wound back in. The big advantage of this system is that should the worst happen, and the camera back comes open by accident, all that you'll lose is the unexposed film still on the take-up spool and across the camera back – your memories are safe and sound inside the cassette. For those used to traditional cameras, it takes a little while to get used to the film counter, which

shows, of course, the number of exposures *remaining*, rather than the number taken.

When you put the film into the camera, and close the back, you'll hear it wind out – it takes about 15 seconds for a 36-exposure roll – and the number 36 will appear in the top-plate LCD panel. If no number appears, and the film cassette icon blinks at you, then you know you've mis-loaded. So start again. Re-open the camera, pull out a *little* more film from the cassette, and close the back once more. Hopefully this time it will wind out.

The Canon EOS 500/REBEL X/S automatically sets the film speed for you, reading it directly from the film, via the internationally-agreed DX-coding system. If you're the careful sort, and want to check that it's set it right, simply rotate the top-plate Command Dial to the "ISO" position, and the film speed will show.

If for any reason you want to over-ride what the camera's set, then all you have to do is rotate the Main Input Dial until the film speed you want is displayed in the top-plate LCD. Then switch the Command Dial back to one of the picture-taking modes. Be aware, though, that any change to the film speed applies only to *that film*. When you put another one in, the camera will revert to the DX system, and read the speed from the film once again. If you want to over-ride you have to do it again.

As you take pictures, the film winds through the camera at the rate of 1 frame-per-second (fps) – and at the end you'll hear a little whirr as it winds the leader in, leaving just the film icon visible in the LCD panel.

REMOVING PART-USED FILMS

At any time you can remove a part-used film, simply by turning the Command Dial as far clockwise as it will go and then pressing the film rewind button to the right of the pop-up flashgun on the top plate. Remember to make a note of the number of shots taken. And do be aware that because of the EOS 500/REBEL X/S's pre-wind system, you won't easily be

able to reload your film into a camera with a conventional film winding system.

FILM TRANSPORT

The film transport system on the EOS 500/REBEL X/S is a continuous advance system, which lets you take one picture straight after another, simply by keeping pressure on the shutter release. Because of this you're always ready for the next shot, and able to take advantage of rapidly changing situations – capturing the decisive moment when action is at its peak. It's also perfect for photographing people – you need never miss a fleeting expression again.

The only thought to bear in mind is that while it's always exciting to hear a motor-drive eating through the exposures, there's a danger that you might get carried away and burn up film unnecessarily. But if you end up with more successful pictures, it's probably money well spent anyway.

AF Mode and Film Winding

Film winding	One-shot	AI Servo
Single frame	The picture can not be taken until the focussing is complete. Setting are made at the same time as the focus. Exposure is determined by evaluative metering. (The exposure value is calculated in advance).	This allows the camera to continuously focus on a moving object. The exposure is set when the shutter is released.
Continuous photography	Continuous shots are taken under the same conditions as above. (About 1 frame per second).	The same conditions as above apply to continuous shots. Focussing is carried out during continuous photography (at the rate of about one frame per second).

THE BUILT-IN FLASHGUN

How many times have you been out taking pictures only to discover that you need a flashgun – either because you forgot it, or because you left it at home to save on weight in your bag. Well, with the Canon EOS 500/REBEL X/S you'll have no such problem, because built into the top of the camera is a versatile and surprisingly powerful little gun that's always there when you need it.

It has a Guide Number (GN) of 12 m/ISO100, and can cover the angle of a 28mm lens. It works particularly well with the EOS 500/REBEL X/S's standard 28-80mm USM, which was specially designed with a narrow barrel to avoid blocking the built-in flash. (See DOs and DON'Ts later in this section for more info on which EF lenses are and aren't compatible.)

The precise distance that the gun can cover depends on a number of factors, including which film is loaded and the maximum aperture of the lens in use. With ISO 100 film the range would be up to about 3m – swapping to ISO 400 film would double the range to 6m.

1. *Press the flash button to raise the flash.*
 • Push the flash gently down to retract.

2. *Press the shutter button halfway to focus on the subject.*

3. *Check that the ϟ symbol in the fiewfinder is on before taking the photograph.*

The exposure you get from the gun is extremely accurate,

because as with the more sophisticated accessory Speedlite 430EZ, the light from the flashgun is read directly from the film by a sensor inside the camera, which then shuts off the output from the flash-tube as soon as enough has hit the film. This "dedicated" system of flash exposure is a very easy to use sophisticated system which delivers incredible accuracy – particularly with its 4-zone sensor, giving three-point evaluative flash metering, which places greatest emphasis on the subject area corresponding to the selected focusing point

If for any reason you want to reduce or increase the output from the flashgun you can do so by pressing the flash button again, which brings into play a clever flash compensation system operated by the Main Input Dial and displayed on the top-plate and viewfinder LCDs.

FLASH DIFFERENCES BETWEEN THE EOS 500 AND THE REBEL XS

At this point it's worth mentioning that there is a small but significant difference between the Canon EOS 500 and the North American Rebel XS model. (The Canon Rebel X, of course, has no built-in flashgun. See the chapter on the EZ Series of flashguns for details of how to take flash pictures with the Rebel X).

CANON EOS 500
The flashgun is **fully automatic** in the Full Auto Green Rectangle mode and in two of the Image Zone modes, Portrait and Close-up. In low-light or backlight, the flashgun pops up of its own accord, fires, and then pops back down. In all of the Creative Zone modes, the built-in flashgun is **activated manually**. You simply have to press down on the Flash Button, which is to the left of the flashgun on the top-plate, and it will fire each time a picture is taken, irrespective of lighting conditions. When you've finished using it you simply put light pressure on the top of the flashgun and push it back down.

CANON REBEL XS
The flashgun fitted to the North American specification Canon Rebel XS model is the same in all respects but one: the gun

must be **activated manually** on every occasion. It will not pop up automatically in the Green Rectangle, Portrait and Close-up modes as it does on the Canon EOS 500/REBEL X/S.

BUILT-IN FLASHGUN – PROS AND CONS

The good thing about the built-in flashgun is its convenience: it's ready, willing and able when you need it. But it does have its drawbacks. The main one is that the top of the camera is probably the worst place to site a flashgun, since it gives a very flat, uninteresting light, with very little modelling. It can also throw ugly shadows behind people, especially if they're standing close to a wall.

In fact, the best place to use the gun is not indoors at all, but outside. Whether it's bright or dull, it's surprising how effective a burst of flashlight can be in improving pictures of people.

On a sunny day, put the sun behind the subject and use the Portrait mode. This will give a well-lit face and hopefully a halo of light around the hair. On a dull day, use the flash in any mode to help lift the colours in the picture.

SETTING THE RED-EYE REDUCTION FACILITY

With the flashgun so close to the lens there's a serious danger that any people in the pictures will suffer from the dreaded red-eye, where the flash light is reflected back from the blood vessels at the back of the eye, making them glow red. To avoid this unwanted effect, you should select the red-eye reduction system using the right of the two buttons in front of the top-plate LCD panel. Press it in once and you raise the flashgun, press it in twice and you set the red-eye reduction facility. An eye icon then appears on the top-plate LCD and in the viewfinder display. What happens in use is that when you press the shutter, a bright light lasting 1.25 seconds is emitted from the lamp between the handgrip, shining briefly into your subject's eyes and causing the pupil to close down and so avoiding their eyes turning red.

1. When the flash is raised, press the flash button (the red-eye reduction mode button) one more time.
• The LCD panel will display the ⊚ mark to indicate that the red-eye reduction has been set.

2. To switch the red-eye reduction function off, press the flash button one more time.

• The ⊚ mark on the LCD panel will go out, indicating that the red eye reduction function has been switched off.

In practice this system works very effectively, although it does take a little getting used to waiting for the lamp to do its business – that 1.25 seconds can sometimes seem like an hour.

USING THE BUILT-IN FLASHGUN IN IMAGE ZONE MODES

The whole point of choosing an Image Zone Mode is that you don't have to worry about any of the technicalities of picture-taking – and that's reflected in the role played by the built-in flash. On the EOS 500, it will pop up and fire, as necessary, in the Portrait and Close-up Modes. On the North American Rebel XS, you need to trigger it by hand.

USING THE BUILT-IN FLASHGUN IN CREATIVE ZONE MODES

In the Creative Zone Modes, the flashgun will not operate automatically – you have to make a conscious decision to use it. Let's look at each of the Creative Zone Modes in turn, and consider how best to use flash with them.

PROGRAM MODE

Using flash in Program Mode is simple, and foolproof. Simply select Program mode as normal and, when you want to take flash pictures, press the top-plate flash activation button. The flashgun will pop up and begin to charge. In the viewfinder you'll see a lightning strike icon, to confirm flash activation,

and a shutter speed of 1/90sec will have been set. If you've set the red-eye reduction facility, you will also see an eye icon in the viewfinder display, and at the point at which you fire the shutter the right-hand display will "count down" as the red-eye reducing lamp fires. Exposure control is automatic, and, in my experience, very accurate.

TIPS ON USING THE BUILT-IN FLASHGUN IN PROGRAM MODE

The obvious time to use the flashgun is when it's too dark to take a picture without it. But in Program Mode it also works well in situations where there is strong back- or side-lighting. In such situations it will give a lower output, fill-in, flash to balance the flash illumination with daylight.

Overall, Program is the most convenient mode in which to use the built-in flashgun.

SHUTTER PRIORITY FLASH MODE

In shutter-priority flash mode, you set the shutter speed and leave the camera to work the corresponding shutter. As you'll see when you try this mode out, the fastest shutter speed the camera will allow you to select is 1/90sec, its fastest synchronisation speed. Turning the Main Input Dial leads to a change in the shutter speed in the viewfinder display, and with a change in the aperture. At certain times the aperture figure may blink on and off repeatedly, this indicates that the camera's exposure system is unable to achieve correct exposure at the settings shown. If, for instance, you set a relatively fast shutter speed in low-ish light, the EOS 500/Rebel X/S may not be able to provide a sufficiently large aperture – and the lens's fastest aperture will flash on and off. If, on the other hand, you set too long a shutter speed, you'll see the lens's minimum aperture flashing.

TIPS ON USING THE BUILT-IN FLASHGUN IN SHUTTER PRIORITY MODE

In practice, if you choose this mode, you'll go for a shutter speed of 1/30sec, 1/60sec or 1/90sec for general picture-taking. Go longer than that, and there's a very serious danger of camera-shake. For creative pictures, where you

want the subject frozen by the light from the flash but the background blurred, you might set a shutter speed of around 1 second and deliberately move the camera during exposure.

APERTURE-PRIORITY FLASH MODE

Aperture-priority flash photography is a useful option in situations where you want to make sure that both the background (lit by available light) and the foreground (lit by flash) are both accurately exposed. The way to do it is to go first into aperture-priority mode (flash down) and take a reading of the overall scene. Make sure the shutter speed is longer than 1/90sec (i.e. 1/60sec, 1/30sec etc). You know that this will correctly expose the scene. If you then maintain those settings and switch the flash on, what you will end up with is a correctly-lit foreground, via the A-TTL flash system, and a correctly-lit background, via the camera's ambient exposure system.

Done correctly, aperture-priority flash mode produces superb results. Try it next time you want to photograph someone in front of an illuminated building at night. It works!

BUILT-IN FLASHGUN DOs & DON'Ts

To make the most of your built-in flashgun, take note of the following hints & tips:

• Don't use lenses with a focal length wider than 28mm, which is the maximum angle-of-coverage of the built-in flash. If you go wider the corners of your pictures will be dark.

• Do be careful when using some specialist and fast-aperture lenses. Some of them are physically large, either in length or size of front element (or both) and block out some or all of the light from the built-in flashgun. They should therefore be avoided. These include: EF 20-35mm f/2.8L, EF 28-80mm f/2.8L, EF 80-200mm f/2.8L, EF 50-200mm f/3.5-4.5, EF 50-200mm f/3.5-4.5, EF 200mm f/1.8L, EF 300mm f/2.8L and EF 600 f/4L.

• Don't use lens hoods, as they too can get in the way. If

fitted, remember to remove them before using the flash.

- Do make sure you remove the plastic hot-shoe cover — with it in place the built-in flashgun won't fire.

Flash Shooting Distance Range
(when using the EF 35-80 mm f/4-5.6 II)

ISO	35 mm		80 mm	
	Negative Film	Slide Film	Negative Film	Slide Film
100	0.5 - 4.2 m	0.7 - 3 m	0.5 - 3 m	0.5 - 2.1 m
400	1 - 8.4 m	1.5 - 6 m	0.7 - 6 m	1 - 4.2 m

GREEN RECTANGLE MODE
Just point 'n' shoot

The Canon EOS 500/REBEL X/S is a very versatile camera. On one hand it's so simple to use that almost anyone can pick it up and within minutes be able to start taking acceptable picture, yet on the other it is so advanced that it can satisfy the needs of a photographic enthusiast for years. How can that be?

Well the secret lies in the way Canon has built in layers of complexity into the camera, allowing the user to take as much or as little responsibility for the technical side of picture-taking as he or she wants.

The starting point is the Green Rectangle mode, created principally with the beginner in mind, but also useful as a "point 'n' shoot" mode for the more experienced photographer.

Command Dial

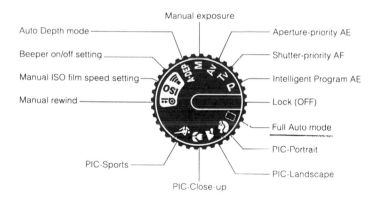

Manual exposure

Auto Depth mode

Beeper on/off setting

Manual ISO film speed setting

Manual rewind

PIC-Sports

PIC-Close-up

Aperture-priority AE

Shutter-priority AE

Intelligent Program AE

Lock (OFF)

Full Auto mode

PIC-Portrait

PIC-Landscape

Set the EOS 500/REBEL X/S to the Green Rectangle position on the Command Dial, and, like Jeeves the butler, the camera will look after everything for you – quietly, efficiently, and automatically. All you have to do is frame the shot and take the picture. It sounds too good to be true, but it works –

magnificently. As you'll see when you get your first set of photographs back from the processors.

For the technically-minded, in Green Rectangle mode here's what the camera actually does:

• use its sophisticated, computerised Evaluative Metering System to assess the scene and set an appropriate shutter speed and aperture, taking account of the sensitivity of the film, the focal length of the lens in use, and prevailing light levels

• with its versatile autofocus system it calculates how far the subject is away, and using a micro-motor built into the lens, focuses the lens – all in a fraction of a second

• ready the built-in flashgun to fire automatically, if required, with red-eye reduction. (Note: the North American EOS Rebel X has no flashgun built-in, and on the Rebel XS the flashgun has to be raised manually).

• set the transport system, and advance the film one frame after exposure.

IN THE BEGINNING

When you first get the EOS 500/REBEL X/S you're likely to welcome the Green Rectangle mode as an excellent way to get started, leaving the camera to work it all out for you while you find your feet and get to know what everything's for. But once you've done that, and you gain in confidence, you'll almost certainly move on to other modes, which will serve you better.

For in reality the Green Rectangle mode is a bit of a compromise. It's good at most things, but in truth excellent at nothing – a jack-of-all-trades-and-master of-none. That said, you may find there are still some situations when the Green Rectangle mode will come in handy.

There may be times when you simply want to take pictures, not practise photography – so you'll welcome having the EOS 500/REBEL X/S set up like a glorified compact.

Or there may be occasions when you want or have to lend the camera to a member of your family or a friend who lacks the ability or experience to use it at a more technical level.

Perhaps, if you have children, you could encourage them to use it (with care!) and so lead them into the exciting and fascinating world of still photography from an early age. We all have a duty to build the hobby for tomorrow, after all.

However you use it, you'll thank the Green Rectangle mode for the start it gave you.

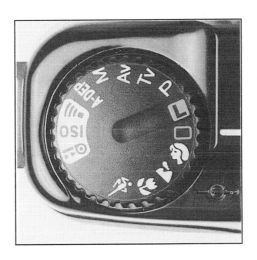

IMAGE ZONE MODES
Automatic shooting made easy

So, while you'll certainly find the Green Rectangle mode a foolproof way of starting to take successful photographs with the Canon EOS 500/REBEL X/S, you'll soon discover its limitations.

The fact is that no one exposure program can tackle every kind of picture-taking situation. Experienced photographers tailor their techniques to the subject in hand, making use of the facilities their camera provides to produce a creative and personal interpretation of the scene, rather than just a simple record of what was there.

Building up the knowledge required to make the right decisions takes time, so Canon have incorporated into the EOS 500/REBEL X/S a collection of more specific picture-taking modes they call **Image Control Modes**. On previous Canon EOS cameras these were called Program Image Control (PIC) modes, but although the name has changed the principles remain the same – namely a pre-set package of camera functions to maximise the opportunities offered by four popular subjects: portraits, landscape, action and close-up.

The great advantage of these modes is that, once again, there's no need to worry about the technical side of things, all the important decisions, about metering, exposure, focusing, film advance and flash are taken for you – completely automatically – leaving you free to concentrate your attention fully on composing the picture.

This makes them not only applicable to newcomers to photography, but also to more experienced picture-takers who want to be sure of capturing every opportunity. Setting the Program Image Control modes is easy: simply rotate the Command Dial until the mode you want clicks into place against the line.

AT-A-GLANCE
CANON EOS 500/REBEL X/S
IMAGE ZONE EXPOSURE MODES

MODE	METERING	EXPOSURE	FOCUSING	FILM ADV.	FLASH
Portrait	Evaluative	Large aperture	One-shot	Continuous	Auto
Landscape	Evaluative	Small aperture	One-shot	Single shot	Off
Sport	Evaluative	Fast shutter speed	AI Focus	Continuous	Off
Close-up	Evaluative	Small aperture	One-shot	Single-frame	Auto

PORTRAIT AUTOMATIC MODE

People love to take pictures of other people. In fact, for many it's the main reason they bought a camera in the first place. And if the government ever passed some crazy law making it illegal to photograph human beings, you could bet your bottom dollar that the great majority of cameras would suddenly lie unused.

Yet far too often our people pictures disappoint. Yes, they offer a reasonable and recognisable likeness, but somehow they fail to go beyond that. What we really want to do is capture their character on film, that indefinable something that makes one person different from another.

To help us achieve that elusive goal, Canon have created a Portrait mode on the Canon EOS 500/REBEL X/S, shown on the Command Dial as a woman's head in a circle. The mode offers a package of features that will help you take better people pictures.

The first thing Portrait mode gives you is continuous shooting, at one frame-per-second, allowing you to take a series of pictures one after the other. Why is that useful? Because the human face is a wonderfully mobile thing, across which in

the space of just a few seconds can run an incredible range of emotions: first laughing, then curious, then sad, then pensive, then angry then ... who knows what?

Catching such fleeting expressions on film is not easy, but is in many ways the secret of successful portrait photography. It requires an alert photographer, with a quick eye and lightning reactions, and a finger always ready on the trigger. When you see the look you want, don't mess about, take several pictures one 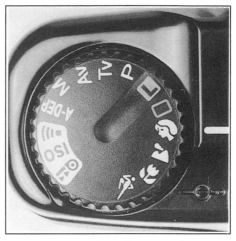 after the other. When you examine them later you'll notice that they're not all the same: the expression or pose will have changed in some subtle way and, if you're lucky, you'll have found what you were looking for.

If you want your people pictures to have impact, you need to fill the frame with your subject — don't have them standing some distance away, go in close. But there is a right and a wrong way to fill the frame.

The wrong way is to use a standard lens and get physically close to the person, perhaps 3 to 4 feet away. This doesn't work, because you'll be entering their personal comfort and making them feel nervous — which is not likely to produce the kind of expression you're after.

The right way is to use a telephoto lens. For general portraits, such as head & shoulders, a focal length between 80mm and 120mm is ideal, giving you a distance of about 6 to 8 feet: close enough to hold a conversation, not too close to be intimidating. The top end of Canon EOS 500/REBEL

X/S's 28-80mm standard lens is perfect for a wide range of people pictures.

Another useful tip is to watch your backgrounds. There's nothing more annoying than shooting a superb set of portraits only to find them marred by a cluttered and distracting background. Going in closer will help solve the problem, but you also need to remember to just look around the edge of the frame before pressing the shutter release, just to make sure there's nothing which will take the viewer's eye away from the person. If there is, move your subject around so the background is as plain and sympathetic as possible.

Luckily the Portrait mode is set up to help minimise the effect of distracting backgrounds by selecting a large aperture such as f/2, f/3.5, f/4, which, because of the way lenses operate, will throw much of what's behind the subject out-of-focus. To help the mode do its work, you need to position your subject as far away from the background as possible – so simply getting them to step a few paces forward can help enormously.

Take care also, when shooting in Portrait mode, to focus very carefully and accurately on the eyes, because if the eyes aren't sharp then the picture will look wrong.

Naturally the camera will automatically sort out all the exposure technicalities for you: this time by selecting its sophisticated Evaluative Metering system and assessing all areas of the scene before making an exposure decision. So in one sense it doesn't really matter what the light's like, you can rely on the camera to make the best of it. But in another sense, the light is very important indeed, and has significant impact on how well the pictures come out.

You might expect that the best light for portraiture would be on a bright, clear, sunny day – but you'd be wrong. The problem is that strong sun casts deep shadows, which look unpleasant under the eyes, nose and chin. If you want to shoot portraits on a bright day, try to find a shaded area, perhaps under a tree, where the light is still strong but less directional. If that's not possible, put the sun behind or to the

side of your subject, so they're not squinting into it, and the EOS 500/REBEL X/S's built-in flash will automatically pop into action (but not on the Rebel X and Rebel XS, where it has to be set manually) and fire to fill-in the shadows. Make sure that you set red-eye reduction to avoid a ghoulish result. The built-in flashgun is also useful for brightening up portraits and giving them a lift on a dull day.

Overall, though, the best light for portraits is found when light clouds cover the sun: you'll get soft, gentle shadows that work wonderfully well.

HINTS & TIPS ON PHOTOGRAPHING PEOPLE

In the section above we've been talking about how to capture someone's character and personality on film by isolating them from the background and concentration on them as individuals. But there is also another approach: the environmental portrait, where the person is shown in a context or situation that says something about them.

Most of the time you have the choice, and it's a matter of photographic intent and personal preference which you go for. When photographing a construction worker, for instance, you could either opt for a close-up of his weathered, sun-tanned and leathery face (character study) or show him working, tools in hand (environmental portrait).

There's a difference in lens use too. Environmental portraits are often taken at a wide-angle setting, between 28mm and 40mm, allowing both subject and surroundings to be crammed into the frame. So you can't rely upon the Portrait mode if you want to shoot environmental portraits, choose instead aperture-priority mode from the range of Creative Exposure modes, and set an aperture around f/11.

Getting people to relax when you're taking their photograph is a great skill, and one that it's possible, and useful, to develop. The problem is that the instant you point a camera at someone and ask them to say "cheese", they become self-conscious and freeze. It's just human nature. And it never seems to matter how well you know them, it still happens – with wooden expressions and poses the result.

A small aperture (wide open) ensures an out-of-focus background.

A slow shutter speed blurs the movement!

There are ways and means of getting them to loosen up, of course. You can chat to them, share gossip, tell a joke – in fact anything that helps them to forget about the camera and become less self-conscious. However, at the end of the day you have to come to terms with the fact that there are a lot of people who do not like having their picture taken.

One option around this is to have a go at shooting some "candids", with them unaware of the fact that they're being photographed. If they don't know you're pointing a camera at them, they're not putting on any kind of act, giving you the best chance of capturing them at their most natural. Here it's best to use a longer length lens if you have one, a zoom covering the range 100-300mm would be ideal. Once again, the portrait mode would be inappropriate – but, because the approach has much in common with sports photography, the Sports mode would work just fine.

LANDSCAPE AUTOMATIC MODE

After portraits, it's landscapes that are the most popular subject for photography. So Canon have provided a mode specially set up to tackle scenic photography, shown on the top-plate Command Dial as hills with a cloud.

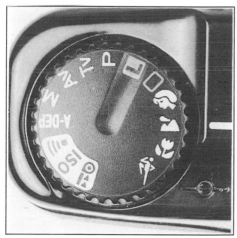

The first thing to say is that there's no hurry when you're taking landscapes. After all, they're not going to get bored and go off and do something else. They've got time on their hands, and they're only too happy to hang around and pose for you for as long as you want. So naturally the camera sets One

Shot focusing and single frame advance, letting you take one picture at a time. No rush, nice and easy: that's the essence of landscape photography.

True, you can sometimes get a more dynamic, faster-changing situation – on a blustery day, with clouds scudding dramatically across the sky, or late in the evening with the light changing rapidly, but One Shot focusing and single frame advance will still cope very nicely thank you.

The most popular way of approaching landscape photography is to use a wide-angle lens together with a small aperture, such as f/11 or f/16, to get a from-here-to-infinity sharpness – and that coincides with how the Canon EOS 500/REBEL X/S's landscape mode is set up.

Precisely what lens you use is entirely a matter of choice. Not long ago 28mm was considered by most photographers to be best, and, if you have one, you'll find a 28mm setting on a standard zoom works very effectively. If you have a standard zoom starting at 35mm, by all means give it a go, and you should be able to achieve some excellent results.

Increasingly, though, wider angled lenses are coming into favour for landscape photography, with 24mm considered the minimum necessary now, and others preferring to go as wide as 20mm. Used carefully, these lenses give a very dramatic perspective – used badly, they produce pictures with little or no impact.

The secret lies in having something of interest in the foreground of the scene, as well as in the middle and background. This gives a sweeping sense of depth, which is why it's important to have a small aperture, so that everything can be kept in focus from front to back.

Be aware, though, that if the camera sets a small aperture it will also be setting a relatively slow shutter speed – which is why so many landscape photographers anchor their cameras firmly to a tripod. Some also use them to help deliberately slow down their picture-taking, which is where we came into this section.

The flash, not surprisingly, is switched off in this mode. Landscapes, by their very nature, tend to be a long way off, and it would be futile to say the least to try to brighten up Stonehenge or the Grand Canyon with the flashgun built into your EOS 500/REBEL X/S – a bit like those poor misguided optimists you see popping a flashcube two miles back at a Michael Jackson concert!

LANDSCAPE HINTS & TIPS

Most photographers, as we've already said, when squaring up to their favourite landscape, will automatically reach into their bag for a wide-angle lens. Well it makes sense, doesn't it? Landscapes are big – aren't they? – so you obviously need a wide-angle lens to cram it all in.

Well not always. Sometimes you can create a more impactful landscape image by using a telephoto lens to pick out interesting details in the distance. A zoom lens in particular, such as the Canon EF 75-300mm or EF 100-300mm, is perfect for cropping the shot precisely how you want it. Be aware, though, that when approaching landscape in this way you should **not** use the EOS 500/REBEL X/S's Landscape mode. It won't give you the effect you're after. Choose instead Aperture-priority from the range of Creative Exposure Modes on offer.

One other thing worth mentioning while we're talking about landscape is how important light is to the subject. Generally – and there are exceptions – landscapes need strong sunlight to bring them to life. But if you can, avoid the middle of the day, when the sun is high, creating high contrast and few shadows. Save your film, take a siesta or have a beer, and come back later, around dusk, when the light is low, skimming across the surface of the Earth and throwing long and highly photogenic shadows.

SPORTS AUTOMATIC MODE

You may have seen professional sports photographers on the television, with their huge lenses as long as your arm and

with front elements as big as a dinner plate, and thought that sports photography was way out of your league. If you're talking major events like the Cup Final or the Open, then you're probably right. Remember, though, that there are lots of smaller, more local events that offer the same big-game thrills but which are a whole lot more accessible. So why not give it a go? True, it's not as easy as portraiture or landscape photography, but who wants to always take the easy option? Sports photography is more challenging, and because of that you'll learn new skills and new techniques which will improve your picture-taking overall. Besides, with just a little practice you'll find that shooting sport isn't that hard after all. Just different.

To get into sports you need to start by setting the Sports mode on the Command Dial, represented by an icon of a sprinter right at the bottom of the dial. As with other modes, this gives you a pre-set package of functions suitable for tackling sport successfully.

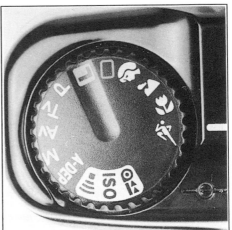

Sport, almost by definition, is about movement, and in many sports the movement is extremely fast. So the first thing you get, not surprisingly, is fast shutter speeds capable of freezing the action. For most situations 1/500 sec is the minimum necessary, and in some sports where there is sudden, explosive action, speeds of 1/2000 sec may be necessary – well within the capability of the EOS 500/REBEL X/S.

At most sports events the subject is some considerable way off, and long focal length lenses – 400mm and 600mm are the most common among professionals – are required to fill the frame with the action. Such long lenses need at least

1/500 sec without support for you to be confident of getting a sharp picture – so the fast shutter speeds set by the Sports mode also help protect against camera-shake.

If the shutter speeds are fast then the apertures will obviously be large, giving limited depth-of-field and a small zone of sharp focus. This is no problem, providing the focusing is accurate, as it should be on the EOS 500/REBEL X/S, with its AI Focus mode. The camera's sophisticated Predictive AF system can track a moving subject, assess its speed and direction, and anticipate its future movement – thus predicting where the subject will be when the shutter opens and the lens focuses. All this happens in a fraction of a second, with pin-sharp pictures the result.

To back this up, the Sports mode of the EOS 500/REBEL X/S also sets Continuous Film Advance, which wind the film through at one frame-per-second.

In any fast-changing situation accurate light metering is essential, so the Sports mode dials in the camera's 6-zone Evaluative Metering system. Sport can throw up some immensely tricky exposure situations, such as a dark-clothed skier against snow, or a sun-lit person in front of a deeply-shaded background. In all these situations the Evaluative Metering system compares the scene to its huge library of lighting situations and makes a judgement based on that. Once again, amazingly, in less time than it takes to blink an eye.

Finally, and obviously, the built-in flashgun is switched off.

SPORTS HINTS & TIPS

The skills needed to be a successful sports photographer are similar to those needed to be a successful sportsman: lightning reactions and constant readiness. It also helps considerably if you know the sport you're photographing – then you can anticipate how the action is going to develop, and when and where the best pictures are going to be taken.

As we said earlier, when starting sport it's a good idea not to

set your sights too high. Start small, start local, build your skills, and *then* look to tackle national events.

Remember, too, that although this is called a "Sports" mode, it can be used to tackle any kind of action photography, from running horses to your children turning cartwheels. Don't be hidebound by definitions.

Nor do you need to feel impeded by lack of equipment. If your only lens is a 28-80mm, fine. Learn to work within its limits – find a sport where you can get close to the action. If you can get hold of a telephoto zoom, one that goes up to 200mm or preferably 300mm, then you have all you need for first-class sports photography.

To make sure the camera is able to set fast enough shutter speeds to freeze the action, especially on dull days or under floodlighting, load up with fast film. ISO 400 is a good, general speed sports film, but if light levels are really dire you may need to go to ISO 800/1000 or even 1600. But be aware that every time you go up in speed you're sacrificing a little quality.

A final thought. Freezing with a fast shutter speed is only one way of capturing action – another option is use a long shutter speed to produce a blurred, more impressionistic interpretation of the subject. Give it a try. You'll have to move away from the Sports mode, though, and try the shutter-priority mode in the Creative Exposure Modes (see next section).

CLOSE-UP AUTOMATIC MODE

Given that the other three Image Zone Modes take in some of the "big themes" of photography you might be surprised to find that the fourth and last is shooting Close-ups. Why on Earth have a special mode for that? But such a view underestimates the superb images you can shoot if you cut away from the wider picture for a while and start thinking small.

Close-up photography opens up a whole new world of

picture-taking, and once you get tuned in to working in this way you'll never find yourself short of interesting close-ups to take. Wherever you are, whatever you're doing, potential subjects will be all around you. All you have to do is select the Close-up mode on the Command Dial, symbolised by a tulip, and you're ready to roll.

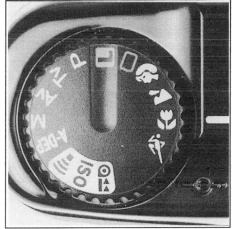

The first thing to say is that the lens you use to shoot close-ups is obviously important. But, contrary to common belief, you don't need a specialist macro lens − although it would certainly help if you did have one. In practice, all that's required is a lens that will let you crop in tightly, to take in an area that's, say, the size of two pages of this book. And most Canon EF standard and standard zooms will do that. Some telephoto zooms have a close-focusing facility too.

One of the big problems of close-up photography is that as you get closer to your subject so it becomes increasingly difficult to keep everything in focus. With that in mind, the Canon EOS 500/REBEL X/S's Close-up mode selects a small aperture, to maximise depth-of-field and keep as much of the scene as sharp as possible. As ever, small apertures can lead to slow shutter speeds, and you're strongly advised to consider using a tripod or other support if the light levels are low.

If they drop too low the camera's built-in flashgun will pop up automatically (but not on the EOS Rebel X and Rebel XS). This can be a mixed blessing, as side lighting is often better for bringing out the pattern and texture of close-ups, with frontal light giving a flatter, more two-dimensional result. So if

you have the option, move your subject to better light and avoid using the flash.

In other modes it's Evaluative Metering that's set, but in Close-up mode the camera goes for Partial Metering, which means it concentrates on the central area, ignoring the surroundings.

The focusing is set to One Shot, and the film advances one frame at a time, since there's little high-speed action in close-up photography – unless you count butterflies, which are notoriously difficult to photograph well.

CLOSE–UP HINTS & TIPS

The secret of successful close-up photography is to change your way of looking at the world. Narrow your field of vision, pay attention to details. Anything with a strong texture or pattern to it will probably make a good close-up shot.

Another way of working is to set up the subject yourself, as a still-life. If you went to the beach, for instance you could collect shells, sand, seaweed, and combine them in an effective close-up. Similarly a walk in the woods would yield leaves and bark and stones. Nip out to your garage or workshop: how about some close-ups of tools or whatever else you might find. Close-up photography is, literally, a whole new world of photography, and the only limit is your mind.

SUMMARY

The four Image Zone Modes have much to offer photographers of all abilities. But once you've got to know them, and have mastered them, it's likely that you'll want to go on to use the Creative Exposure Modes a lot more – although there will certainly be times, as with the Full Auto Green Rectangle mode, when you'll want to return and make use of them.

CREATIVE EXPOSURE MODES
Doing it for yourself

Image Zone Modes are like package holidays: because everything is organised for you, they're safe, secure ways of getting to strange and unfamiliar places – in this case the many and sometimes mysterious worlds of photography.

But when you reach a certain stage in travelling you don't want to be held by the hand any more, you want to go your own way, do your own thing. Okay, so you may get lost along the way, and make some mistakes, but that can be a good thing – because you discover new things, and you grow.

So it is with photography. Sooner or later you'll start looking beyond the the pre-set Image Zone Mode packages and start wanting to take more control yourself, and start thinking about rotating the Command Dial *the other way*, towards the Creative Image Modes. Doing so will mark a turning point in your picture-taking, as you start to make more things happen yourself, rather than relying on the camera to do it for you. And your photography will improve because of it.

Of course not so long ago, before Image Zone Modes and Program Image Control modes were invented, Creative Exposure Modes were all we had, which forced us at a much earlier stage to understand some of the principles of photography. The positive side of that is obvious – people got into the creative side of picture-taking sooner. The negative side was that some didn't make it, put off by all the technicalities.

But now cameras such as the Canon EOS 500/REBEL X/S offer more of a progression. You don't start by abseiling from a height of 200ft blindfold. You build your confidence and skill by doing it with your eyes wide open from 40ft first. So start with Image Zone Control, and when you feel ready, make the move to Creative Exposure Modes.

FIVE MODES TO CHOOSE FROM

The EOS 500/REBEL X/S offers a choice of five Creative Exposure Modes. Why so many? Well, once again, it's all about giving the photographer choice: different subjects require different treatment, and different people have different ways of working.

If you're a new photographer you'll have an open mind and be willing to try any and probably all of the modes on offer. But if you're an experienced photographer you may well have established ways of working which you'd prefer to continue with.

I, for instance, have spent many years using cameras in aperture-priority mode, so I still tend to, even when there are other options available to me. I feel comfortable and in control if I choose the aperture first, that's the way I naturally think about photography, and that's the way I take my best pictures.

Some of you will almost certainly be long-time Canon users, and will have owned, and may still do, Canon's excellent AE-1 and AE-1Program cameras from the 1980s. These were unusual at the time in that they were based around a shutter-priority mode, and you may have formed a habit of selecting the shutter first and want to keep working that way.

At the end of the day, it really doesn't matter one iota. The key thing is getting the right amount of light on the film, and all of these modes do that, and do it very well. You now have the luxury of choosing the one which best fits your style of photography, and that can only be a good thing.

Of course, it's important to remember that getting the right amount of light on the film isn't enough. It's how you do it, what the specific combination of aperture and shutter speed is, that produces the creative effect you're after.

PROGRAM (P) MODE – WHAT IT DOES

Program Mode is the most automated of the Creative

Exposure Modes, setting both the aperture and the shutter speed automatically for you. Because in the EOS system the camera and the lens are interactive, that is they "talk" to each other, the camera is well informed when it comes to making decisions. At any time it "knows" what the focal length of the 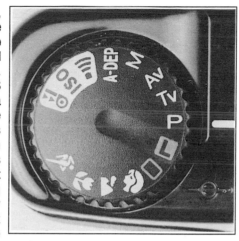 lens is, and if it's a zoom what position it's set at; the point the lens is focused on; and its maximum and minimum aperture.

Of these it's the first, the focal length of the lens, which is most important because one of the Program Mode's priorities is setting a shutter speed fast enough to reduce the danger of camera-shake. So with a 50mm lens the Program mode would try to set a shutter speed of 1/60 sec or faster; with a 200mm lens it would be 1/250 sec or faster; and so on. Having done that, it will go for a middle-of-the-road exposure balance: favouring neither small nor large apertures, neither fast nor slow shutter speeds.

However, at any point you can over-ride the combination of aperture and shutter speed which the camera has chosen, simply by rotating the Main Input Dial. As you do so you'll see in the viewfinder display and on the the top-plate LCD the shutter speed and aperture change – but of course the exposure level itself will remain the same.

Arguably, then, you need never switch out of Program. Since with a quick spin of the Main Input Dial you can vary the aperture/shutter speed combination without altering the exposure level at all.

PROGRAM (P) MODE – WHEN TO USE IT

Program Mode can be relied upon a lot of the time, and many photographers do so. It's ideal for general picture-taking, where there's nothing you particularly want to achieve creatively.

However, like the Full Auto Green Rectangle mode, it can be a bit of a compromise, producing pictures that are a little bit bland. It's convenient, but not particularly creative. You might like to try either the aperture- or shutter-priority modes to see if they fit your photography better. It's amazing what a change of approach can do. Thinking in different ways might result in you taking different pictures.

APERTURE-PRIORITY (Av) MODE – WHAT IT DOES

Aperture-priority mode lets you choose the aperture and sets a corresponding shutter speed to give correct exposure. The importance of the aperture is that it controls the "depth-of-field" in the picture.

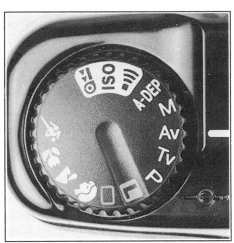

Depth-of-field is a concept which many photographers half-understand and which makes the eyes of others glaze over in terror. But the principle is pretty simple. Depth-of-field is the size of the "zone of sharpness" in front of and behind the point you actually focus on which will appear sharp in the finished picture.

Setting a small aperture (big number), such as f/11, f/16, f/22, gives lots of depth-of-field – that is, there will be an extensive zone of sharpness.

Setting a large aperture (small number), such as f/1.8, f/2.8, f/4, will give limited depth-of-field – that is there will be a limited depth-of-field.

Many successful photographers think in terms of depth-of-field, and the question they ask themselves before they start to take pictures is, "Do I want lots of depth-of-field or just a little?" – and then they set the aperture accordingly.

At the same time some account has to be taken of what's happening to the shutter speed, to ensure that setting a small aperture won't result in a long, camera-shake-inducing shutter speed.

APERTURE-PRIORITY (Av) MODE
– WHEN TO USE IT

It probably goes without saying that the time to use aperture-priority is when the aperture is important – but when is that? Isn't it all the time? Well, to some extent that's true. But the aperture is particularly important in situations where you either want extensive depth-of-field, to get as much of the picture as sharp as possible, or where you want limited depth-of-field, to restrict the zone of focus.

For a more detailed discussion of depth-of-field, check out the section on the Depth Mode below.

SHUTTER-PRIORITY (Tv) MODE
– WHAT IT DOES

Shutter-priority works in the opposite way to Aperture-Priority Mode, letting you choose the shutter speed and setting the corresponding aperture to give correct exposure. On the EOS 500/REBEL X/S you have a wide range of shutter speeds, from 1/8000 sec to 30 seconds in half-stop stages. The "Tv" in the mode heading stands for Time Value.

Command Dial

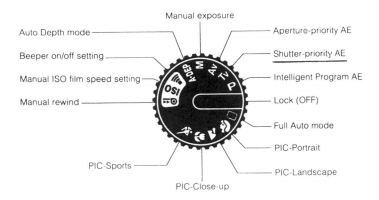

Manual exposure

Auto Depth mode

Beeper on/off setting

Manual ISO film speed setting

Manual rewind

PIC-Sports

PIC-Close-up

Aperture-priority AE

Shutter-priority AE

Intelligent Program AE

Lock (OFF)

Full Auto mode

PIC-Portrait

PIC-Landscape

SHUTTER-PRIORITY (Tv) MODE
– WHEN TO USE IT

The obvious situations in which you'd want to use shutter-priority are when the shutter speed is more important than the aperture. The times when this will be the case are when you want to stop action or blur it, or defend against camera-shake.

Learning what shutter speed to use for action is largely a matter of experience. At first, if you want to freeze action, you should go for the fastest shutter speed circumstances will allow, and then experiment with slightly longer speeds. Using longer shutter speeds to blur action is less clear cut, because there is always a matter of judgement about what is successful and what is not. It all depends on how fast the subject is moving and where you are in relation to it. Generally it's best to pan along with the subject, that is follow it with your camera and lens as it moves across you, firing the shutter as you do so. "Panning" like this will hopefully give you a subject that is largely sharp against a blurred background. Try shutter speeds of 1/15 sec, 1/30 sec and 1/60 sec to start with.

MANUAL (M) MODE – WHAT IT DOES

In manual mode you set both shutter speed and aperture yourself, guided by a display in the viewfinder and on the top-plate. This sounds good, but do be aware that it can be a doubled-edged sword that can cut both ways.

The up-side is that you have complete creative control over

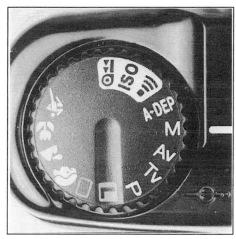

exposure. The down-side is that it's a whole lot easier to make mistakes. Serious ones. Get your exposure wrong, and it'll be like the bad old days, and your picture *won't come out*. Let me say this, as someone who has spent many years using cameras with manual exposure systems: you might, if you're really skilful, *sometimes* take a better picture in manual mode. Basically I'm a convert to technology. With sophisticated metering systems such as those in the Canon EOS 500/REBEL X/S you really don't need manual metering any more.

But enjoy playing with it if you want. When you switch to it, you'll see the exposure compensation dial in the two displays change, and it will give you an indication of how much the camera believes you'll over- or under-expose at present settings.

MANUAL (M) MODE – WHEN TO USE IT

My advice would be to stay away from Manual mode until you're very experienced and understand the principles of exposure fully. Situations in which you may then want to switch to Manual are to dabble in the Zone system or if you need to copy some old pictures or other flat artwork.

BULB SETTING – WHAT IT DOES

The Bulb setting is accessed by turning the Command Dial to M and then turning the Main Input Dial past 30 seconds until the word "bulb" appears in the LCD panel. Bulb lets you open the shutter for a long as you want to achieve a range of creative effects.

BULB SETTING – WHEN TO USE IT

The only time you would want to use the bulb setting is when you need an exposure that's longer than 30 seconds – if it's up to 30 seconds then it makes sense to use one of the other modes. And 30 seconds is a long time in photography – an exposure that long will handle all but the worst night and low-light situations. The kind of thing you might use it for are streaking the trails of moving cars and photographing fireworks. In situations such as that, make sure the camera is firmly anchored to a tripod, set a small aperture, and fire the shutter with a remote release.

THE DEPTH-OF-FIELD MODE (A-DEP)
– WHAT IT DOES

As we saw a moment ago, using the aperture to control how much of the scene appears sharp in the finished picture is one of the keys to creative photography. Generally, what you want to do is get everything sharp, from the foreground right through to the background. You can do it, as we discussed, by using the Aperture-Priority Mode. But it takes time and trouble to work it all out.

So Canon have made it easy for you, by providing on the Canon EOS 500/Rebel X/S a mode that's dedicated to keep everything in sharp focus. All you have to do is turn the Command Dial to the A-DEP position, frame the shot, and then press the shutter release halfway down. Using its multi-point focusing sensors, the camera measures the various subject distances in the scene, and selects an aperture and focusing point that will keep it all sharp. This aperture,

together with its corresponding shutter speed, is then displayed on the LCD panel and In the viewfinder.

At this point it's imperative that you check the shutter speed. Why? Because in some situations, the aperture required will be very small indeed, and that will force the camera's exposure computer system to go for a very slow shutter speed – possibly one that will cause camera-shake if you don't support the camera in some way.

Assuming you're happy with the shutter speed, press the shutter release down the rest of the way, and the picture will be taken.

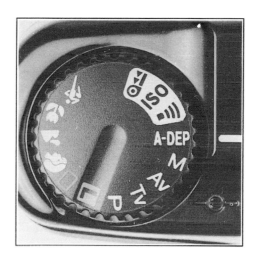

EXPOSURE COMPENSATION
Fine-tuning exposure

No automated exposure system, however good, is ever 100% accurate. So the Canon EOS 500/REBEL X/S offers you a number of ways of fine-tuning your exposure to increase your success rate.

But before we go further into this, we need to ask an interesting and pertinent question: if Evaluative Metering really is as good as Canon says it is, why do we need exposure compensation?

And the answer is: increasingly we don't. Having now taken many hundreds of pictures on the Canon EOS 500/REBEL X/S, of a huge range of subjects, in just about every kind of lighting situations you could think of, I'm happy to report that I've suffered very few failures. Most of the time I've relied completely on the camera's Evaluative Metering, and the vast majority of the time my faith in it has been rewarded with accurate exposure.

Exposure Compensation:

1. Set the command dial to the creative zone.

2. Press the shutter button halfway to focus on the subject.
* *The shutter speed and aperture will be indicated on the LCD panel and in the viewfinder.*

3. While pressing the exposure compensation button, turn the electronic input dial until the exposure level mark is set to the desired exposure compensation amount.
* *"+" will increase the exposure level, "-" will reduce it.*
* *To cancel exposure compensation, set the exposure level mark on the exposure level mark scale to* ⓪.

4. Take the photograph.

To be perfectly honest, if you only ever shoot print film, which has tremendous exposure latitude, you could probably afford to skip this chapter as it's unlikely that the camera will ever fail you. That said, of course it's useful to understand fully all the camera's features and what they can do for you. If you shoot slide film, though, or expect to, then you should certainly continue reading.

The key to understanding when you might need to give exposure compensation depends upon your ability to recognise the "tricky" situations in which exposure meters are prone to failure. Here's a list to watch out for:

8 SITUATIONS WHEN YOU MIGHT NEED TO GIVE EXPOSURE COMPENSATION:

1. **When the background is very light,** such as sand, sea, snow or a white wall. This can cause the meter to under-expose, and render your main subject too dark. Solution: increase exposure by around 1 and 1/2 stops.

2. **When the background is very dark**, such as a sunlit figure in front of a deep shadow or a spot-lit performer on stage. The meter may over-expose, "burning out" your main subject and making the background muddy. Solution: reduce exposure by approximately two stops.

3. **When there is a light source in the picture,** the meter can think that the scene is brighter than it really is, and so under-expose. Solution: increase exposure by between 1 and 2 stops.

4. **When there's lots of sky in the picture,** the meter may under-expose, especially if you turn the camera on its side. Solution: take an AE-Lock reading from the ground excluding the sky.

5. **When you're shooting into-the-light,** if you accept the meter reading you may end up with under-exposure. Solution: increase exposure by around 2 stops.

6. **When your subject is standing in front of a window,** the effect is the same as shooting into the light, and the solution the same: increase exposure by around 2 stops.

7. **When your subject is very dark,** the meter will assume that there's a range of tones and therefore increase exposure, making your subject come out grey. Solution: reduce exposure by between 1 and 2 stops.

8. **When your subject is very light,** under-exposure will result. Solution: typically 2 stops additional exposure will put things right.

USING THE AE-LOCK BUTTON

The secret of exposure accuracy lies in exposing for the subject, not the whole scene. Which is why the Canon EOS 500/REBEL X/S's AE-Lock button is so useful, it lets you choose the part of the picture that's important, and from which you want to meter, limiting its coverage to 9.5% of the viewfinder area for increased accuracy. All you have to do is go in close to the subject, take a reading, press in the AE-Lock button to hold onto it, return to your original picture-taking position, compose, and take your shot. You're virtually guaranteed spot-on exposure.

USING THE EXPOSURE-COMPENSATION SYSTEM

The Canon EOS 500/REBEL X/S has a superbly-designed exposure compensation that's very easy to operate. Simply engage the AV +/– button with your right thumb, and then turn the Main Input Dial with your right-hand index finger – clock-wise to increase exposure, anti-clock-wise to decrease it. The degree of exposure correction is shown clearly in the top-plate LCD panel and in the viewfinder LCD. The camera allows you to increase or decrease exposure by up to 2 stops, in half-stop increments.

EZ-SERIES FLASHGUNS
When you need more power

The built-in flashgun is good for everyday picture-taking and to get you out of trouble. But sooner or later you're going to find it limits your creativity, and you'll need to think about investing in a more powerful and more versatile gun.

There are several guns in the Canon Speedlite range. The ones you're most likely to consider are the Speedlite 200E, the Speedlite 300EZ, and the Speedlite 430EZ.

For owners of the Canon EOS 500/Rebel X/S, the 200E is not really worth considering. It's barely more powerful than the built-in gun, and offers no new features.

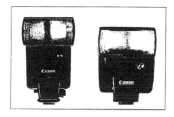

Canon Speedlite Flashes include the powerful 430EZ zoom flash, which clips on to the accessory shoe and has a maximum guide number of 43m at ISO 100, m, and the 300EZ, which has a maximum guide number of 9.14m at ISO 100, m.

The Speedlite 300EZ is a good flashgun. With a Guide Number of 30 (m/ISO100), it's sufficiently more powerful than the integral flash. It also has a zoom head, covering focal lengths from 28mm to 70mm, a rapid fire mode, and a creative Second Curtain Synchronisation mode.

But if you're serious about your photography, then the flashgun you should aspire to owning is the superb Canon Speedlite 430EZ. With a powerful Guide Number of 43 (m/ISO100) it's capable of covering a distance of about 19m with a 28-80mm zoom. Used with a lens with a faster maximum aperture, that distance will increase even further.

Like the Speedlite 300EZ it has a zoom head, this time covering a slightly bigger range, from 28-80mm. As well as zooming, the head will also bounce and swivel, allowing you to bounce light off a wall or ceiling to give a much softer, more pleasing effect. To ensure that you always get a pure

white light with no colour cast - some people paint their ceilings pink and what colour the walls? - a good investment is one of the highly portable "Lumiquest" pocketbouncers, which, used in the bounce position, ensure you do not get 'Red Eye' and will always provide the same quality of bounced white light. This is infinitely better than the in-your-face blast of a forward-facing head.

Like the small built-in gun, the Canon Speedlite 430 EZ interfaces electronically with the camera, via an A-TTL dedicated system, which, to give outstandingly accurate flash exposures, balances the flash light with ambient light to give natural-looking results.

Creativity is one of the 430 EZ's strong points. It offers "second-curtain" synchronisation, which improves the photography of moving subjects by timing the flash to fire at the *end* of the exposure, not the beginning. It also provides a Stroboscopic flash option, in which it fires a succession of flashes, up to 10 per second, to capture movement. You may have seen pictures of this type, often of golf swings or ballet, in photographic magazines such as *Practical Photography* or *Photo Answers*. The secret, as with Multiple-Exposures, is to use a black background, so that your flash-lit subject stands out sharply and clearly.

All-in-all, the Speedlite 430EZ will give you pretty much anything you'd ask from a flashgun. It's solidly-made, with understandable, easy-to-use controls, and a clear display panel.

THE HEART OF A SYSTEM

Not only is it a great flashgun in its own right, it can also form part of a sophisticated flash system. A wide range of leads and connectors is available to allow you to use the 430EZ off-camera, or in conjunction with other Canon Speedlite guns. And the good news is that even when you do so, you maintain the accurate A-TTL flash exposure dedication, as well as retaining all of the gun's functions.

For heavy users, there are also powerful battery packs.

These shorten recycling time (the time it takes for the gun to recharge between flashes) and delivers more flashes per set of batteries. If you take a lot of flash pictures, you'll find it worthwhile investing in one.

LIGHTING FOR MACRO

Standard Speedlites are fine for general picture-taking, but next-to-useless for serious close-up photography. What you need is the ML3 Macro Ring Lite, a flashgun that's circular and which screws onto the front of the lens. It's designed specifically for the EF 50mm f/2.5 and EF 100mm f/2.8 Macro Lenses.

It contains two flash tubes, each of which can be turned off for creative shadow control. The Guide Number is a useful 11 (m/ISO100), and naturally the unit gives full Auto TTL flash exposure control.

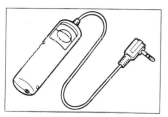

Remote Switch RS-60E3

The remote switch RS-60E3 is attached to the camera's remote control jack and is intended for use when taking macro or long exposure shots (such as bulb shots) using a tripod. The special cable release avoids shaking the camera.

Eye-piece Extender EP-EX15

The eye-piece extender EP-EX15 extends the EOS viewfinder by 15mm. Attaching the extender increases the magnification of the viewfinder by about 0.5.

OTHER FEATURES
Multiple-exposure & self-timer

SHOOTING MULTIPLE-EXPOSURES

If you've got a lively imagination, and have always fancied having a go at "trick photography", then this one's for you. The Multiple-Exposure function on the Canon EOS 500/REBEL X/S is your chance to get really creative by combining up to 9 different images on a single frame of film.

Think of all the things you could do! Include the same person twice, maybe having a fight with himself. Show a sequence of events. Merge images, such as a glamour shot of a girl, and a sea. Add a sun or moon to a landscape or night shot. The list, quite literally, is endless. The only limit is your imagination.

HOW TO SET THE CANON EOS 500/REBEL X/S UP FOR MULTIPLE-EXPOSURES

To set the Multiple-Exposure function you press in the two buttons at the back of the camera near the right thumb, and you'll see overlapping rectangles and the number 1 appear on the top-plate LCD display. While continuing to hold the buttons in, you turn the Main Input Dial to the right – and you'll see the number change. This indicates the number of Multiple-Exposures, and goes up to a maximum of 9. When you've chosen the number you want, release the buttons on the back, and the display will return to normal – but with the double rectangles and the number of multiple-exposures selected still showing.

As you begin your series of multiple-exposures, the double rectangles on the LCD panel start to flash, and the multiple-exposure counter in the bottom right-hand corner counts down, to tell you how many shots you've got left in this sequence.

When you've finished, the camera automatically reverts to single-exposure photography, and if you want to shoot

another multiple-exposure sequence you need to repeat the procedure outlined above.

Naturally in the course of shooting the main frame counter is de-coupled, so it only counts up the number of exposures used, not the number of multiple-exposures taken. That is, even if you shoot a 7-shot sequence, you'll only add 1 to the film exposure counter.

Multiple-exposure Photography

With multiple-exposure photography you can release the shutter to expose the same frame of film two or more times to obtain special effects.

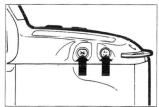

1. Set the command dial to the creative zone.

2. Press the partial metering and the exposure compensation buttons at the same time. The ▄ symbol will appear on the display.

3. While holding down both the partial metering and the exposure compensation buttons, set the number of multiple-exposures required using the electronic input dial.

• The number of multiple-exposures will appear on the film counter of the LCD panel.

• The number of multiple-exposures can be set up to 9.

• To cancel the multiple-exposure function, reset the number of multiple-exposures to 1.

THE SECRETS OF SUCCESSFUL MULTIPLE-EXPOSURES

Shooting multiple-exposures used to be a difficult and messy business, but thanks to modern technology, it's now very easy to do. Unfortunately it's still very easy to do it badly. So here are a few pointers to set you on the road to shooting successful multiple-exposures:

- If you've never done any multiple-exposure work before, shoot your first sequence in front of a black background, and make sure that no objects or people overlap. This will do away with the need to worry about exposure and will keep things relatively simple.

- Once you've got the hang of that, you can spread your wings and fly a little, and try your hand at something more demanding. The important thing to remember is that as soon as parts of the scene start to overlap you'll need to adjust your exposure. So if, for instance, you merged two faces, one on top of the other, then you would need to halve the exposure for each – i.e. use the exposure compensation system to under-expose each by around 1 stop. To be sure of getting one image that's right, shoot several sets at different exposure settings.

- Remember you can change lenses in the middle of a sequence, so one possibility might be to shoot the same scene at up to nine different positions on a zoom lens. Filters, too, can be added to creative effect.

- For the really serious, you don't have to be limited to nine multiple-exposures on a frame. When the counter gets down to one you can call up the M-E system and dial in 9 again. So in fact there's no limit to the number of shots you can put on one frame.

USING THE SELF-TIMER

The most obvious and traditional use for the self-timer is to include yourself in the picture. You set the camera up, on a tripod or some other support such as a convenient wall, frame a shot of family and friends, activate the self-timer, and

then sprint around in the 10 seconds provided, joining the group just in time to say "cheese".

And it's still as useful to be able to do that as it always was. There's nothing worse than looking through your holiday pictures only to find you're not in any of them. That's the trouble with being the photographer in the family, you can easily end up as the invisible man!

But there is another use you can put the self-timer too, which may not come as immediately to mind – and that's to help prevent camera-shake. Suppose you're out taking landscapes, and toward the end of the day, as the light levels begin to fall, you have before you the most exquisite scene you have ever witnessed in your life. You have *got* to get this on film, but it's getting too dark to hand-hold, so you find a suitable support, and then you look in your bag only to find – darn it! – that you've left your remote release at home. What can you do, apart from tear your hair out? Simple: use the self-timer. Once it's set, and you've pressed the shutter release, the camera has 10 seconds to stop wobbling, and you should be assured of shake-free pictures.

And setting the self-timer on the Canon EOS 500/REBEL X/S couldn't be easier. On the far side of the top-plate LCD panel are 2 buttons. Press in the left-hand one, and the self-timer is activated and ready to roll, with the self-timer icon making an appearance in the LCD panel to show it's been set. Then all you have to do is fire the shutter in the normal way. Once the lens has focused, a "10" appears in the LCD panel, and begins to count down – 9, 8, 7 – to the accompaniment of a 2-beeps-per-second audible confirmation. With 2 seconds to go this suddenly speeds up to a rapid rat-a-tat-tat, telling you it's time for you and the rest of the crew to get your smiles in place.

To cancel the self-timer, simply press in the same button once.

PICTURE-TAKING
WITH THE EOS 500/REBEL X/S

We've talked a lot so far about what the Canon EOS 500/Rebel X/S can do in theory, and the aim of this section is to build on that by taking a look at practical picture-taking with the camera. We'll be considering a wide range of photographic techniques, from getting sharp pictures through to developing an eye for a picture. Some of the techniques are simple, others more advanced.

GETTING SHARP PICTURES

The starting point in photography is taking sharp pictures. It's essential. Because no matter how good your shot may be in terms of content, subject matter, composition and all that, you'll find it doesn't amount to a hill of beans in anyone else's eyes if it's not sharp. So your priority, *every single time you take a picture*, is to ensure that it comes out sharp.

One of the major reasons for blurred pictures is camera-shake, and that's caused by movement of the camera during the course of exposure. If you're using the Canon EOS 500/Rebel X/S on one of its automated programs, the chance of camera-shake is relatively slim. The sophisticated exposure and metering system will try to set a shutter speed that's sufficiently fast to avoid camera-shake – and will warn you, either via an audible beep or by a flashing light, if camera-shake is likely.

Even so, you have to hold the camera steady – and this is an area in which photographers vary greatly in their ability. Some are as solid as a rock. Others wobble like jelly. Wherever you start from in terms of natural ability, you can get better. It's all a matter of practising as often as you can with an empty camera. Always remember to squeeze the shutter release v-e-r-y g-e-n-t-l-y, even when – especially when! – you're faced with an exciting subject which you're eager to photograph. Don't get carried away. Stay controlled. And never *jab* at the shutter release.

Be sure to hold the camera properly. Don't let your arms

hang loosely in front of your body. Tuck your elbows in close, and pull the back of the camera tight against the eye.

For even greater stability, try bracing yourself against something. This could be upright, such as a lamp-post or fence, or horizontal, such as a wall or the bonnet of a car. Better still, use a proper support if you can. If you really want to be sure of sharp pictures, make a tripod your permanent companion.

Another way of ending up with unsharp pictures is to focus inaccurately. Clearly, with the Canon EOS 500/Rebel X/S, blessed as it is with an advanced Multi Wide Focusing system, poor focusing is less likely. But it's still possible, and you can't simply trust the camera to focus for you. As we discussed in the chapter on the Autofocus System, the camera will automatically choose which of its three focusing points it will use to focus on. Now because it obviously can't read your mind, and doesn't know what's the important part of the scene, it can make mistakes. So keep an eye on what it's up to.

If you see that it's focusing on the wrong area, you can override the automated system in one of two ways: you can either use the "*" Partial Metering button, which selects only the central focusing point, or you can switch to manual focus, using the switch on the lens.

COMPOSITION

Composition is just like breathing. Most of the time we do it automatically, without thinking. Yet we can, whenever we wish, take full control of it.

Think for a moment about how you take pictures. Do you consciously decide how to arrange the composition? Probably not. More likely you intuitively organise the various elements within the frame in a way that looks right to you. Trouble is, after you've been taking pictures for a while, you tend to get into a routine as far as composition is concerned. And little by little, whatever the subject matter, all your photographs start looking the same. They become – dare we

admit it? – boring and predictable. But it doesn't have to be that way. You can take control of the situation, simply by paying conscious attention to the process of composition. It's time for an injection of new ideas. Here are a few thoughts to get you started.

FOCAL POINTERS
When taking a picture you need to be clear what it's about – and that will determine its focal point, its centre of interest. That doesn't mean it should be in the centre, if anything quite the opposite. Pictures with the subject in the centre tend to look static and boring. So experiment by placing your focal point at various positions in the frame, and see how it looks. You may find that the more towards the edge you put it, the more tension you'll create.

THE RULE OF THIRDS
One of the best-known "rules" of photography is the so-called rule of thirds, which suggests that you mentally divide the picture area into nine equally-sized sections, like a noughts-and-crosses grid, and make sure the focal point lies at one of the intersections. It derives from art theory, and no-one has ever really been able to explain how it works, but if you take a look at your own best pictures, it's odds-on that a lot of them will be composed according to the rule-of-thirds.

GO WALKABOUT
The most powerful and versatile compositional weapons in your armoury will cost nothing and be readily available. They're your legs, and used wisely they can save you lots of wasted film, and help you take a few more masterpieces to boot.

You see, with a static subject, such as a landscape or a building, and a little time at your disposal, it's always a good idea to have a nice little wander around before committing anything to film. Take a look at the scene from every conceivable angle, and then, and only then, when you've carried out your reconnaissance, should you start actually taking pictures.

See 'Focal Pointers' and 'On its Side'
Picture taken by the Author

Try experimenting with the camera on its side -
ideal for portraits

HIGHER AND LOWER

Most pictures are taken with the camera somewhere between 5 and 6 feet off the ground – because generally people use them when they're standing up. But success in photography often comes from giving the viewer a new way of looking at things, a new perspective on a familiar scene. And often a composition will be improved no end if you go for an alternative viewpoint. Climb a hill, go up a ladder, and everything looks completely different. Lie on your back, or at least squat down, to get a worm's view of proceedings.

MOVE CLOSER

Too many amateur pictures contain acres of wasted space with the whole point of the picture just a tiny dot in the frame. So don't stand back and include unnecessary detail, get in close and crop in to where the action is. There are very few pictures that don't benefit from stepping a few paces forwards, so give it a try.

NEW HORIZONS

In landscapes and seascapes, one important thing you have to decide is where to put the horizon. Do you want it across the middle? The result ends up a bit static. Why not try putting it much lower or higher in the frame?

ON ITS SIDE

As strange as it might seem, some people never think of turning the camera on its side to give an upright shot, but it's better for all sorts of pictures: portraits and buildings, to name but two popular ones. The horizontal format is more balanced, the upright one more dynamic.

DYNAMIC DIAGONALS

And creating a dynamic result, a sense of something happening, is important in photography, if you want to bring a 2-dimensional still image to life. One of the most effective ways of doing that is to look for diagonal lines to include in your shots. They are powerful because they lead the eye into the picture, and then through it, creating a sense of depth and movement.

BETWEEN THE LINES

Lines in general are important because they give pictures direction and motion. The eye is attracted to them and follows them, creating involvement for the viewer in "reading" the picture.

MAKING THE SUBJECT STAND OUT

Another way of making the two-dimensional image more 3-dimensional is to make part of the scene stand out by the way you control depth-of-field. Use a telephoto lens, 100mm plus, at a large aperture, f/2,8, f/4, or f/5.6, to photograph a subject that's some way in front of the background, and you'll get a strong and striking result, with the subject seemingly projected forward out of the picture. This technique is sometimes also called differential focusing.

FRONT TO BACK SHARPNESS

The opposite technique is to make everything sharp. This is best done with a wide-angle lens and a small aperture, such as f/11 or f/16. For it to be effective, you need to have something in the foreground, middle and background.

FRAME IT

Continuing the theme of creating depth, always be on the lookout for natural or man-made frames that you can exploit to make the foreground more interesting. Things like bridges, trees and archways can make charming and effective compositional tools.

COLOUR COMPOSITION

Another way of considering composition is to think about how the colours in the picture relate to each other. Some scenes have strong colour contrast, which makes for vibrant, dramatic shots, especially in bright sunlight. Others display colour harmony, with subtle tones, say of green and gold in autumn.

BREAK THE RULES

The important thing to remember is that there are no "rules" of composition. Only guidelines. When it comes to

composition, there ain't no right and there ain't no wrong. What works, works. What doesn't, doesn't. Try some of the ideas on these pages. If they work for you, fine. If not, discard them.

Whatever you do, before you press the shutter release ask yourself two questions:

1) is there anything distracting in the scene which will mess it up, such as having a telegraph pole sticking out of someone's head, or a distracting person wearing a red jacket walking into the picture.

2) how can I make this picture more exciting.

Do that, and you won't go far wrong.

LENSES

One of the reasons that many people choose to buy a Single-Lens Reflex camera such as the Canon EOS 500/REBEL X/S is the enormous wealth of picture-taking opportunities opened up by being able to fit a range of different lenses.

And one of the most important decisions you make, every time you take a picture, is which lens to use. Nothing else has more effect on how the finished shot looks, so it's important that you give the matter serious thought. But how do you decide which lens to use in any particular situation?

Well, as in many other areas, there's a large degree of personal preference. Some photographers just like the way things look photographed through a telephoto lens while others prefer the perspective offered by a wide-angle.

Then there's the kind of pictures you take. If tightly-cropped portraits are your forte, then you won't be using a wide-angle much. And likewise if you shoot a lot of sweeping vistas, your telephotos won't get much exercise.

All lenses have different properties, and one of the skills of photography is selecting the right lens for the job.

Most photographers use wide-angles when they want to get a lot more in the frame, and there's no denying that they're unbeatable when space is limited, making them suitable for landscapes, groups of people, architecture and interiors. But it's not enough to just point your wide-angle at the scene and let it swallow everything whole. You're likely to end up with a boring picture that lacks any centre-of-interest. The right time to use wide-angles is when you want to create really dramatic pictures: go in close, so the foreground looms large, while the background races with the speed of Linford Christie into infinity.

Telephotos are also much misunderstood. Yes, of course they're useful for magnifying your subject when you can't get close enough – as in sport or wildlife – but that's not all they do. What they're really great for is isolation of detail. As we said earlier, far too often photographers try to include everything before them in the picture. Generally, though, they'd do better to select just a small part of it – for instance head & shoulder portraits are generally far stronger than full-length studies.

Zooms offer the best of all worlds. With a standard 28-80mm zoom, you can go from a decent wide-angle to a moderate telephoto in a second or so. That gives you great picture-taking versatility. And you need never miss a picture for want of a lens.

USING LIGHT

Light is the single most important element in any photograph. Bar none. It is, quite literally, the raw material of photography. Try taking a picture without any!

Yet it's frightening how few photographers pay any real attention to it. Most of the time they're so eager to press the shutter release that they don't even bother to consider which direction the light's coming from, what kind of light it is, and whether there's any way they can improve on it. If you want to become a better photographer, get to know light. Study its moods and learn what it does.

Daylight is very variable: different times of the day, different times of the year, and different weather conditions alter the nature of daylight. It's important to understand the characteristics of each of the kinds of light, and how to control, modify and improve it, to produce the result you're after.

There are four main ways in which light varies: in output, in direction, in colour, and in concentration or diffusion. And there are four main types of daylight.

BRIGHT SUNLIGHT

For many photographers, picture-taking and sunshine go together like the proverbial peaches and cream – and as soon as you see the sun with his hat on, you can guarantee a posse of photographers won't be far behind.

The association of photography with the sun is a long-standing one, dating back to the days when films were so slow it wasn't possible to take pictures when it was overcast. But today's sophisticated cameras, such as the Canon EOS 500/Rebel X/S, will produce satisfactory results even in the worst of weather.

Even so, bright sun remains a popular time to take pictures. But is it the best? Well, it depends how you use it. Most photographers who keep the sun over their shoulder, as they've been taught, will be disappointed by the results: bleached out colours, deep downward shadows, enormous contrast, and in portraits, people squinting. That's what you'll get if you shoot at around noon.

But whenever possible you should shun the middle of the day, and put your film to better use before 10am and after 4pm, when the lower angle of the sun produces longer, more photogenic shadows, and has a pleasing warmth to it.

An alternative is to risk the wrath of Kodak, and vary your position in relation to the sun. Do that, and a wide range of creative results is possible.

Side-lighting, for instance, gives more tone and modelling,

especially if you use a white cloth or board to bounce back light into the shaded side of the face.

For even more dramatic results, try shooting into-the-sun, or contre-jour, as it's often known. If you leave things to the meter, you'll probably end up under-exposed – although if you're lucky you might just get a dramatic silhouette. Choose instead to use the camera's built-in flashgun, which will blip a little light into the subject, but leave them surrounded by a golden halo of light. Beautiful!

LIGHT CLOUD
A better light for most subjects is that which you get on a bright sunny day with just a little light cloud. As the clouds pass over the sun, they soften and diffuse it, producing a very pleasing light that's directional, but not harsh. The resulting soft shadows make the light perfect for a wide range of subjects, especially portraiture and landscape. The only real disadvantage is that it doesn't offer the same degree of colour saturation as the brightest sunlight, but it does more than make up for it in terms of texture and tonality.

HEAVIER CLOUD
Days when the sun is covered by too much cloud can result in pictures that lack "bite", because there are few shadows. Used carefully, for the right subject, it can work. But most of the time the results will be a bit bland and uninteresting.

OVERCAST
The worst light of all comes on days when it's heavily overcast. There are no shadows at all, light levels are poor, and the light often has a bluish cast. The best thing to do is go home, grab a drink, put your feet up, and read a nice photo magazine until things get better.

Simple scenes often make surprisingly good pictures, and all you have to do is be aware of their potential. Here a handful of leaves resting on the grass in the shade of a tree produce a pleasing composition.

Photo : Steve Bavister

You don't need exotic lenses to create enjoyable photographs - just an interesting subject. Here a British postbox is brought to life by the "raking light" of evening and captured with a 50mm standard lens.

Photo : Steve Bavister

A 24mm wide-angle lens conveys some of the excitement of Las Vegas, with lines cutting dramatically across the frame. An aperture of f/16 keeps everything sharp, producing a shutter speed of 1/60 sec. to blur the moving cars.

Photo : Steve Bavister

Diagonals make dramatic pictures - as this shot of a "Bateau Mouche" on the Seine in Paris, France demonstrates. High viewpoints often present interesting and unusual perspectives that show things in a new and unusual light.

Photo : Steve Bavister

Used with care, filters can enhance a picture. Here, the addition of an 81B filter warms up the scene so that a shot taken at noon resembles one taken later in the day.

Photo : Steve Bavister

The people you come across may not be as photogenic as this Japanese cook, but whoever you photograph you'll find the Canon EOS 500/Rebel X/S's portrait mode invaluable.

Photo : Steve Bavister

Colours can be appealing in their own right, and can be the whole
point of a picture, as here in a shot taken in the picturesque
Cotswold village of Broadway.

Photo : Steve Bavister

Las Vegas is renowned for its neon lights, offering a wealth of picture-taking opportunities for the photographer who likes to go out after dark. Take a tripod with you, though, and use a cable release.

Photo : Steve Bavister

Candids often make attractive pictures, as with this pensive moment for a British fox-hunter, captured with a 100-300mm zoom, set to 200mm.

Photo : Steve Bavister

Details are often more interesting than the whole scene. Here, the boat on the beach is pleasant enough, but the graphic close-up of its side makes a more graphic photograph.

Photo : Steve Bavister

FILM CHOICE

The truth is, there are no bad films. But different brands and different types do have different characteristics. The ideal way to choose the right type for your particular brand of picture-taking is over a period of time to try as you can afford, choose just one or two you really like, and then stick with them, till you've learnt what they can and can't do.

WHICH FILM SPEED?

The most important thing to decide when buying a film is what "speed" you want, because this has an enormous effect on the quality and look of the end results. The speed is simply a measure of how sensitive it is to light, as expressed by its ISO (for International Standards Organisation) rating. The system is simple. Fast films with relatively high numbers are more sensitive to light than slow films which have low ISO numbers. In practical terms, fast film needs less light to give a particular exposure than slow film.

SLOW: ISO 25 TO 80
There are many benefits to using slow film: fine-grain, great sharpness, saturated colours. But there are practical difficulties. You're okay shooting in bright light, but in any other situation you may need a tripod. If you want maximum quality, this is the one to go for.

MEDIUM: ISO 100 TO 200
These films offer a good balance of sharpness and speed, and are an ideal general-purpose film. With recent launches in this category there are now some superb quality products from which to choose.

FAST: ISO 400 TO 800
Going up to ISO 400 plus, you get extra usable speed, which you may need if you want to capture fast-moving action or keep taking pictures in less than ideal conditions. However, you also get significantly poorer grain and sharpness, and flatter colours.

ULTRA-FAST: ISO 1000 UPWARDS

These films have coarse grain and soft tonality, so I would recommend you only use them in situations where a relatively poor picture is better than none at all, or if you want to experiment and try something a bit different.

WHICH FILM TO CHOOSE?

Since few of us will use up a complete roll on one subject, we need one that will handle a whole range of different situations. So most of us should steer a path between fast and slow and come up with a compromise, but a sensible one, of choosing a film speed around ISO200.

PRINT OR SLIDE

It depends pretty much on what you intend to do with the pictures. If you want pictures which you can hand round to friends and relative, or to mount and frame, then choose print. If, on the other hand, you want to put on a show that will blow people's socks off, or start selling your work, then it's slides you must go for.

If you're a beginner, start with prints, until you're getting consistent results. Slides are extremely temperamental of exposure errors, and prints are more forgiving.

COLOUR OR BLACK & WHITE

This is simply a matter of personal taste. A huge proportion of people shoot nothing but colour – simply because they want natural, lifelike results. The advantage of mono is that it interprets reality rather than simply recording it. The sensible photographer uses both, selecting whichever suits the subject and situation in hand.

"SEEING" PICTURES

Once you've had your camera a little while, you'll find you've exhausted all the obvious picture-taking opportunities – family, friends and places you go to – and you'll start to think "What's next?".

This is a dangerous time, and the danger is that you won't come up with an answer – and you'll start to lose interest in

photography, and go off and do something far less interesting instead.

But the fact is, there are literally hundreds and thousands of picture-taking opportunities all around you every day of the year. And what you have to do, to sustain your interest in photography, is train your eye to "see" photographs where others will miss them.

A good way to do this is to set yourself a series of projects to work on. Photograph patterns and textures for a while. Or reflections. Or buildings. Or animals. Or whatever it is that takes your fancy. Follow your interests.

Keep a notebook of ideas, so that when you get a few spare minutes you can nip off and get stuck into some photography without having to worry "What shall I shoot?".

Whatever you do, enjoy your photography.

LENSES FOR THE
CANON EOS 500/REBEL X/S

There's a good chance that you bought the Canon EOS 500/Rebel X/S with a standard zoom lens such as a 28-80mm. If so, it will take you some time before you start to exhaust its possibilities. But sooner or later you'll start thinking about buying another lens to widen your picture-taking horizons, and you'll find yourself hanging around in photo stores and turning the pages of photo magazines longingly.

The first thing you have to decide is whether you want to go longer or wider – and as we discussed earlier, the decision depends largely on what sort of pictures you like taking.

If you're into wildlife, sport and candids, then you need something longer, probably one of the excellent range of

Canon EF telezooms.

If, on the other hand, your leaning is toward photographing big buildings or creating dramatic perspective in landscapes, then you need to consider one of the range of Canon EF Ultra-wide-angles lenses.

Eventually, of course, you'll want to build up a complete system, a bagful of lenses that will allow you to cover every eventuality.

WHY CHOOSE CANON EF LENSES?

As well as Canon lenses, there are other brands of lenses on the market, many of them at very attractive prices compared to those made by Canon. Why should you buy Canon? Well, there are a lot of good reasons:

- Canon's lenses are renowned for their sharpness, contrast and colour quality – and at the end of the day it's the quality of the results you get back from the lab that's the most important thing. Canon is the leader in the use of aspherical glass elements, fluorite crystal and Ultra-Low Dispersion (UD) glass, and their lenses are optically second to none.

- As the Canon EOS 500/REBEL X/S itself shows, Canon are at the cutting edge of photographic design, and that is as true for their lenses as it is for the cameras themselves. From the beginning every EF lens has contained its own custom-designed autofocus motor and electromagnetic diaphragm, providing fast and accurate focusing and exposure. But with the introduction of Ultrasonic Motors (USM) into the lenses, Canon have moved even further ahead of the game. Fit a Canon EF Ultrasonic Lens to your camera, such as the EF 28-105mm zoom, and you'll be amazed at 1) how quickly it focuses, and 2) how quietly it focuses. Canon have declared that their dream is to produce lenses which are as quick and as quiet as the human eye. On the basis of the EF USM lenses currently available, they're very close to achieving that dream.

- A strong advantage of buying Canon-made lenses is that

you're guaranteed compatibility not only with the current system, but also with what is to come in the future. Who knows what models Canon may introduce this year, next year or the year after? But you can be certain they will do everything possible to ensure that the lenses currently available work on future models.

- Another factor worth considering is that Canon lenses are styled cosmetically to match and look good with each other and with other Canon camera bodies – that's not also true of independent lenses.

- Although they're designed primarily for autofocusing, Canon's lenses can all still be focused very effectively by hand, and are provided with sufficiently wide, serrated focusing rings to that end.

- And finally, Canon now have a huge number of lenses in their EF range, over 40, with something to meet every photographic need you have now or are likely to have in the future. Let's take a look at some:

EF LENSES FOR THE
CANON EOS 500/REBEL X/S

ULTRA-WIDE-ANGLE EF LENSES
If you're looking for dramatic pictures, look no further than the two ultra-wide-angle EF lenses from Canon. Their eye-popping perspective produces pictures that certainly get people talking. Even the most mundane scene takes on a magical shape with one of these on your camera.

Try the **EF14mm f/2.8L USM** for photographs that seem to go from here to infinity, with depth-of-field like you've never seen before.

Or have a go with the the Fish-eye **EF 15mm f/2.8**. It's a full-frame fish-eye with an incredible 180 degree angle-of-view. See it swallow up the world, and watch in amazement as straight lines go bendy and distortion takes over. Take care you don't get your feet or fingers in the picture!

WIDE-ANGLE EF LENSES

Whatever your wide-angle need there's a lens to meet it in the Canon EF range. One of the latest to be added is the **EF 20mm f/2.8 USM.** This superb lens takes in a sweeping perspective and is ideal for landscapes and architectural shots with impact. Keep the camera straight and you get natural, square perspective. Tilt the camera back and you'll see converging verticals make all the lines go diving diagonally in, towards some distant vanishing point.

The **EF 24mm f/2.8** and the **EF 28mm f/2.8** offer a more "normal" wide-angle perspective – that is they take in a lot more than a standard 50mm lens, but without the distortion you get from wider focal lengths.

Very few people buy 35mm wide-angle lenses these days, perhaps because they seem a bit tame compared to what else is on offer. Even so, it's good to see that Canon have the **EF 35mm f/2** in their range for those who want one.

If you're a wide-angle kind of person through-and-through, why not take a look at the incredible **EF 20-35mm f/2.8L.** It covers all the popular wide-angle focal lengths in one compact lens, has a fast maximum aperture of f/2.8, and is incredibly sharp. Call it wide-angle heaven! It's not cheap, but then the best never is.

STANDARD LENSES

In many ways it's a shame to see standard lenses falling from favour in the face of the rise in popularity of the standard zoom, because they have so much going for them: a fast maximum aperture that makes low-light shooting possible, close minimum focus, and incredible sharpness. The **EF 50mm f/1.8 MkII** is a great standard, and with a weight of only 130grams you hardly know you've got it on the camera. Not so the outrageously-fast **EF 50mm f/1.0L USM**, the fastest standard lens ever made for an SLR, which weighs over seven times as much. If you need speed, this is it.

STANDARD ZOOMS

The new **EF 28-80mm f/3.5-4.5 USM,** with which many EOS 500/REBEL X/S cameras will be sold, is a first-class general-

purpose lens, and one of a number of Canon EF standard zooms on offer. If you own or have owned a Canon EOS 1000/Rebel, you may have used one of the **EF 35-80mm f/4-5.6 USM** and **EF 35-105mm f/4.5-5.6 USM** lenses sold with that camera. If you'd like more coverage at the telephoto end of the scale, choose instead the **EF 35-135mm f/4-5.6 USM.**

For some people, though, 35mm won't be wide enough at the bottom end, and they'll opt for a lens that goes down to 28mm. The first choice here is the **EF 28-80mm f/3.5-5.6**, a neat, attractive lens at a sensible price. At the top-end of the standard zoom scale is the professional **EF 28-80mm f/2.8-4L USM**, designed for optimum optical performance, particularly in the suppression of flare.

TELEPHOTO LENSES
Sales of fixed focal length telephoto lenses have been steadily declining with the increase in popularity of telephoto zooms. But they still have a great deal to offer the discerning photographer: principally sharpness and speed.

Lenses in the range 85 to 100mm are widely know as portrait lenses, because of the flattering perspective they give to pictures of people. Canon have three lenses in this range: the **EF 100mm f/2 USM,** the **EF 85mm f/1.8 USM**, and the **EF 85mm f/1.2L USM.** All focus down to around 3 feet, and their fast maximum apertures are very useful for throwing backgrounds out of focus and concentrating attention on the subject.

Sadly, the 135mm focal length seems to have gone the way of the 35mm – few people are interested in it these days. But the Canon **EF 135mm f/2.8** has something else to offer beyond its focal length – a continuously-variable soft-focus option that's ideal for creating a romantic mood, instantly.

If it's a little more pulling power that you're after, then consider the **EF 200mm f/2.8L USM** and **EF 200mm f/1.8L USM**. Both will give you a bright, clear viewfinder image and good sharpness, but the f/1.8L version, built with professionals in mind, weighs 3000grams and is 200mm long.

As you go beyond the 200mm, you get into long- or super-telephoto lenses. These are rarely used for general picture-taking – anyone buying one usually has a specific interest in mind. This could be photographing birds, other wildlife, sport – they're even used by fashion photographers on the catwalk. There are five super-telephoto EF lenses: the **EF 300MM F/4L USM, EF 300MM F/2.8L USM, EF 400mm f/2.8L USM, EF 500mm f/4.5L USM** and **EF 600mm f/4L USM**. All are hellishly heavy – book those weight-lifting sessions now!

TELEPHOTO ZOOMS

Most people buy their EOS camera these days with a standard supplied, so the first lens they look to add is often a telephoto zoom – often now shortened to telezoom. And in the Canon EF range they're spoilt for choice.

One of the most affordable telezooms on offer is the **EF 80-200mm f/4.5-5.6 USM**, but that doesn't mean any corners have been cut. You get the same commitment to sharpness that you do in a more expensive optic. The difference lies in the maximum aperture, which is not as fast as the pro-specification **EF 80-200mm f/2.8L**.

If you want a bigger range than the 2-and-a-half times ratio of the 80-200mms, then the **EF 70-210mm f/3.5-4.5 USM** could be your cup of tea.

If you want a stronger telephoto effect, but still prefer a zoom, you might like to investigate the three Canon EF zooms that go up to 300mm. One of the most popular is the **EF 100-300m f/4.5-5.6 USM**, a fast-focusing lens that's tremendously sharp. If the faster maximum aperture isn't important to you, then go for the more attractively-priced **EF 100-300mm f/5.6L**. For those who want to cover all telephoto bases, the **EF 75-300mm f/4-5.6 USM** is the ultimate Canon telezoom.

MACRO LENSES

If playing with the Close-up Automatic mode on the Canon EOS 500/REBEL X/S has caught your imagination, then you might think of buying one of Canon's special macro lenses. There are two: the **EF 50mm f/2.5 Compact Macro** doubles as a standard lens but gives magnification up to half life-size

– full life-size when used with the Life Size Converter EF. Using a 50mm macro can put you a bit close to your subject, and if you prefer more working room give the **EF 100mm f/2.8 Macro** a try. Without accessories it gives 1:1 life-size reproduction, and also makes a perfect portrait lens.

TILT-SHIFT LENSES

If you ever need to take pictures where the perspective is just right, perhaps of buildings where everything must be square, then you need the three specialist Tilt-Shift lenses in the Canon range: a **24mm f/3.5L, 45mm f/2.8** and **90mm f/2.8** are available.

EXTENDERS

Extenders, or teleconverters as they're sometimes known, are simple accessories that fit between the lens and the camera body, and offer a relatively inexpensive way of increasing the versatility of your current lens's range.

Canon make two extenders: **EF 2x** extender which doubles the focal length of any lens you use it with, and **EF 1.4x**, which increases focal length by 40%. Both are intended for use with any fixed focal length lens from 200mm to 600mm.

ACCESSORIES
Useful add-ons

CANON 60T3 REMOTE SWITCH

Everyone knows that it's essential to use a tripod when you have a long exposure time, otherwise your picture will be ruined by camera-shake. Even the slightest movement at the moment of exposure can take the edge of sharpness away.

However, supporting the camera so it doesn't move isn't enough on its own. You have to make sure you don't cause any vibration when you release the shutter. Which means you can't press down on the shutter release in the normal way.

What you need is the Canon Remote Switch RS-60E3. This has a 2.5mm jack lead that fits into the socket on the right-hand side of the camera, and allows you to fire the shutter electronically from up to 60cm away.

GR-80TP GRIP EXTENSION

This neat little accessory serves two purposes. One, it makes the camera slightly bigger to hold, and, two, it features a handy built-in mini-tripod that will give stable support on any level surface.

LENS HOODS

Canon lenses are made to the highest possible quality. But some of that quality can be lost when taking pictures around bright light sources. This can cause flare. The solution is a simple one – fit a hood to the end of each lens, which help prevent stray light hitting the front element.

FILTERS

Filters are a cheap and very cheerful way of increasing your picture-taking options. For little outlay you can enter whole

new worlds of photography. Sadly, there is not space here to consider the many filters on the market. But four I would recommend to all photographers are:

***Skylight/UV**. This should be left on the camera all of the time, for two reasons. Firstly, it protects the lens. Imagine that someone accidentally caught an ice-cream cone on the end of one of your precious Canon lenses – and you have no filter. Goodbye optical quality, hello big repair bill. Filters, on the other hand, are relatively cheap to replace. Secondly, Skylight/UV filters absorb Ultra-Violet (UV) light. We can't see it, but film is sensitive to it, resulting in blue and slightly unsharp pictures when it's present – most notably at the coast or near mountains.

*Soft-focus
Modern lenses are very sharp, and that can be a problem. Sometimes you want to emphasise mood in a picture, rather than record maximum detail. So you need a soft-focus filter in your bag. This diffuses the image by spreading the highlights, giving a romantic treatment that's ideal for a whole host of subjects, from portraits to landscapes to still-life.

*Graduated
Graduated filters, commonly know as grads, are particularly useful for landscape, travel and architectural photography. They're half-coloured, so if you position them correctly, they darken the sky but leave the foreground unaffected. They're great on days when the sky is pale and washed out. For general use, go for a blue or grey grad.

*Polarizing filter
Although more expensive than other filters, the polarizer is one you really must have. In summer it's totally indispensable – deepening blue skies and separating them from fluffy white clouds, saturating colours of all kinds, and eliminating reflections from water, glass and other non-metallic surfaces. And the great thing is you can see the effect in the viewfinder – as you rotate them you see the sky darken and lighten.

OP/TECH STRAP
Although the Canon EOS 500/REBEL X/S is one of the lightest SLRs on the market, you might find that when fitted

with a telezoom lens, such as the excellent 100-300mm f/4-5.6 USM, it can get tiring after a while - if you use a normal strap, that is. However, if you fit one of the elasticated, cushioning straps made by Op/Tech – available from all good camera stores – you'll be able to tote the camera around all day without a care in the world.

Op/Tech - The world's most comfortable camera, bag and tripod straps (binoculars too). Op tech has a built-in weight reduction system that makes equipment feel 50% lighter and 100% more comfortable. From the famous 'Pro-Camera Strap' to the 'Bag Strap' and the 'Tripod Strap', the style, colours and comfort which, along with the non-slip grip, ensure that you have a wonderful combination of comfort and safety.

MAXIMISING POWER
Extending the life of your battery

The Canon EOS 500/REBEL X/S, like most modern cameras, is totally dependent on battery power. Take out the batteries, or let its power run down to nothing, and your state-of-the-art picture-taking machine is as dead as the proverbial Dodo.

And Sod's Law dictates that your battery will always die at the worst possible moment, such as in the middle of your daughter's wedding. So you need to make sure you're not caught out, and there are two sensible things you can do:

1. Pack a spare set. The EOS 500/REBEL X/S uses 2 DL123A or equivalent, a 3-volt lithium battery. Compared to other types of battery, such as manganese and alkaline types, lithium batteries have a very good shelf-life – that is they hold their charge for a long time unused – so it's worth having a spare set should you need them unexpectedly.

 Canon claim that a set of fresh DL123A lithium batteries will power the EOS 500/REBEL X/S for up to 60 rolls if the flash isn't used, up to 25 rolls if flash is used half the time, and up to 12 rolls if flash is used all the time.

 That's a useful guide on how long you can expect the battery to last, but there are so many other factors involved (see below) that you can never be sure. Taking a look at the top-plate LCD panel battery check indicator on a regular basis is also worthwhile – you'll see then when the batteries are getting to the stage of needing to be replaced. If "bc" is visible, indicating that the batteries are at the point of imminent exhaustion, change them *now*.

2. DL123A batteries are expensive, so it's worth getting as much use out of them as possible – and that means using the camera wisely and carefully. Because the camera is electronic, there are a great many things which the battery is called upon to do – some obvious, some less so. Here they are:

* **POWER ALL THE MOTORS:**
 * film wind and rewind
 * focus the lens
 * stop down the lens aperture

* **POWER THE BUILT-IN FLASHGUN:**
 and auxiliary focusing lights

* **POWER THE INFORMATION PANELS:**
 * top-plate LCD
 * viewfinder LCD

* **FIRE THE ELECTRONIC SHUTTER**

Some of these you have little or no control over, except in respect of how many pictures you take. Others you can affect. Overall, you should avoid:

* **Focusing unnecessarily.** This can put a very big drain on the battery, especially if you use long lenses that need powerful motors to focus them. Playing about with the camera to see what it can do is fun − but can eat into battery life dramatically.

* **Using the built-in flashgun unnecessarily.** As we saw above, excessive use can drain batteries quickly. It may work out more economical in the long run to buy a separate, accessory flashgun which uses cheaper, alkaline, AA-type batteries.

Other things you can do to conserve power are:

* **Switch the Command Dial to L** whenever the camera is not in use, disconnecting the battery from the camera's electronics.

* **Remove the batteries completely,** if you know you won't be using the camera for a period of time.

CANON EOS 500/REBEL X/S QD
Data-back model

There is also a data-back version of the Canon EOS 500/REBEL X/S, called the QD (quartz date), sold in some markets, which will automatically imprint, in orange, a range of date information directly onto the bottom right of the negative/print or slide.

The back incorporates a built-in automatic calendar programmed with dates up to the year 2019, and the date and time can be imprinted in one of four different formats – or, if preferred, switched off.

The options are, and pressing the Mode button changes the format in the following sequence:

1. Year/Month/Day.
2. Day/Hour/Minute.
3. No Imprint.
4. Month/Day/Year.
5. Day/Month/Year.

It's also possible to change the date and time when travelling to a different time-zone. Here's how:

1) Press the Mode button to display the date/time on the LCD panel

2) Press Select so that the first setting position to be changed begins to blink, then press Set to input the number you want

3) Repeat Step 2 until everything is set. When you've finished, press Select again, until all positions stop flashing.

REMINDER!: The data-back is powered by a 3-volt CR2025 battery with a life of around 3 years. When the LCD panel becomes hard to read you'll need to change it. The battery is positioned inside the camera back, clearly visible, under a cover which you'll need to loosen to get access.

CANON EOS 500/REBEL X/S
Specification at-a-glance

Type: 35mm focal-plane shutter Single-Lens Reflex (SLR) camera with autofocus, auto-exposure, built-in flash and built-in motor-drive

Lens mount: Canon EF mount (electronic signal transfer system)

Viewfinder: Fixed eye-level pentaprism showing 90% vertical and horizontal of actual picture area with 0.70x magnification with 50mm lens at infinity.

Dioptric adjustment: Built-in eyepiece is adjusted to -1 diopter.

Focusing Screen: Fixed, full-surface with all speeds electronically controlled.

Shutter: Vertical-travel, focal-plane shutter with all speeds electronically controlled.

Shutter Speed: 1/2000sec – 30 seconds and bulb, set in 1/2 step increments.

X-sync speed: 1/90 sec.

AUTOFOCUS

AF Control System: TTL-SIR (Secondary Image Registration) phase-detection type using 3-point Cross-type BASIS (BAse-Stored Image Sensor).

Autofocus Modes Available: Two: One-shot AF and AI Servo with Focus Prediction that automatically switches to One-Shot or AI Servo according to subject. Manual Focusing also possible.

AF Working Range: EV1 – 18 at ISO 100.

AF Auxiliary Light: Built-in AF auxiliary light fires automatically when necessary.

EXPOSURE CONTROL:

Light Metering: TTL (Through-The-Lens) full-aperture metering using a 6-zone SPC (silicon photocell). Two metering modes available: 6-zone evaluative metering, and central partial metering which covers approx. 9.5% of finder area.

Metering Range: EV2 – 20 with 50mm f/1.4 lens at ISO 100.

Shooting Modes: Program AE; Shutter-priority AE; Aperture-Priority AE; Depth-of-Field AE; Full Auto; Programmed Image Control (Portrait, Landscape, Close-up, Sports); Flash AE; and Manual Exposure.

Camera Shake Warning: Operates in Green Zone and Programmed Image Control modes. Shutter speed blinks.

Multiple-Exposures: Up to nine can be pre-set – automatically cleared upon completion.

Exposure Compensation: +/–2 stops in 1/2 stop increments.

FILM TRANSPORT

Film Speed Setting: Automatically set according to DX Code (ISO 25-5000) or set by user (ISO 6-6400).

Film Loading: Automatic prewind system. Film auto-matically winds to the end of the roll when the back cover is closed.

Film Wind: Automatic. One of two modes is automatically set: Single Frame and Continuous (1fps maximum).

Film Rewind: Automatic rewind at end of roll.

OTHER

Self-Timer: Electronically controlled with 10-second delay indicated by a beeper tone.

POWER SOURCE

Battery: Two three-volt lithium CR123 A types.

SIZE:

Dimensions: 145mm (w) x 92mm (h) x 61.9mm (d).

Weight: 665g (body only, no battery)

BUILT-IN FLASH

Type: Retractable-type, auto pop-up, TTL automatic exposure flash housed in pentaprism.

Guide Number: 12m (ISO 100)

Flash Coverage Angle: Covers the field of view of a 28mm lens .

Recycling Time: Approximately 2 seconds

Flash Duration: 1ms or less.

Shooting Distance Range: up to 3.29m with ISO 100 film.

X-Synch Speed: Fastest sync speed 1/90 sec.

AF Auxiliary Light: Automatically emitted when the shutter button is pressed half-way if necessary. Effective distance range: 5m.

Red-eye reduction: applicable in all shooting modes.

DATE FUNCTION: QD Model Only:

Type: Built-in Date/time imprinting function using dot LED with automatic calendar programmed with dates to 2019.

Date Imprint Formats:

1. Year/Month/Day.
2. Day/Hour/Minute.
3. No Imprint.
4. Month/Day/Year.
5. Day/Month/Year.

Imprint Colour: Orange

Clock Precision: Variation of +/– 90 seconds or less per month.

Power Source: One dedicated 3v lithium CR2025. Approx life: 3 years.

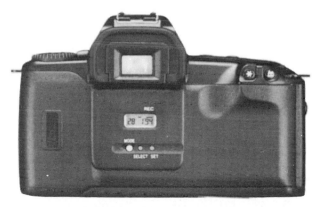

Canon EOS 500/Rebel X/S with Data-back